C000216819

Memories from Pembroke Dock

KEN MACCALLUM

AMBERLEY

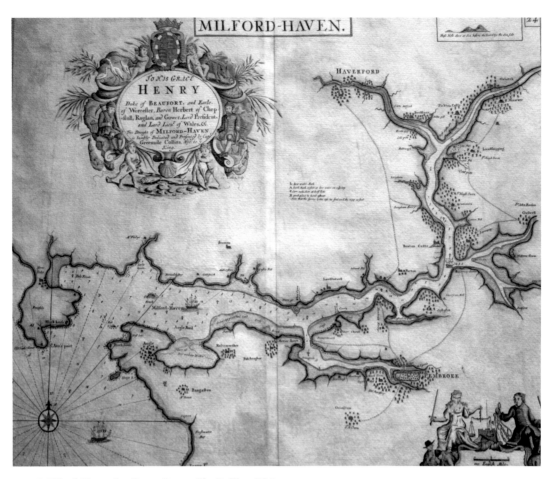

Milford Haven by Capt. Greenville Collins, RN, *c.* 1798.

First published 2014

Amberley Publishing
The Hill, Stroud
Gloucestershire, GL5 4EP
www.amberley-books.com

Copyright © Ken MacCallum, 2014

The right of Ken MacCallum to be identified
as the Author of this work has been asserted in
accordance with the Copyrights, Designs and
Patents Act 1988.

ISBN 978 1 4456 2183 8 (print)
ISBN 978 1 4456 2198 2 (ebook)

All rights reserved. No part of this book may be
reprinted or reproduced or utilised in any form
or by any electronic, mechanical or other means,
now known or hereafter invented, including
photocopying and recording, or in any information
storage or retrieval system, without the permission
in writing from the Publishers.

British Library Cataloguing in Publication Data.
A catalogue record for this book is available from
the British Library.

Typesetting by Amberley Publishing.
Printed in the UK.

Contents

Foreword

Pembrokeshire has always been a good place for storytelling; Pembroke men are born tellers of tales and have never been short of a story. The words, 'I minds the time, boy, when' have begun many a recollection, sometimes slightly embellished for effect, but always entertaining. Their common element was good humour and they were seldom told to someone's disadvantage. The master of the craft was my old and valued colleague from the *Western Telegraph*, the late Vernon Scott, who will be warmly remembered.

Personal recollections are an important part of our community history. Ken MacCallum of the Pembroke Probus Club, in an initiative to mark the bicentenary of Pembroke Dock in 2014, encouraged club members to write down some of their reminiscences of days gone by. They responded with enthusiasm. Most, but not all, of the writers were Pembroke born. The common thread is that all are South Pembrokeshire residents in this bicentenary year of Pembroke Dock. Most of the stories capture memories of Pembroke Dock and the area in the Second World War: the bombing of the admiralty oil tanks and wartime life on a Pwllcrochan farm. One story recalls post-war work in the old Royal Dockyard. Other memories range beyond the shores of Milford Haven. John Russell recalls his service in Bomber Command and Ken MacCallum relates a wartime sea passage home from Singapore in 1939 when he was aged just five.

This is a varied and wide-ranging collection of personal stories. What a joy if something similar had been produced in 1914. This book is a valuable contribution to the bicentenary of Pembroke Dock. It will be read with much interest now and even more so in years to come.

Lawrie Phillips
Late of Pennar

Preface

Ken MacCallum

The development of South Pembrokeshire can probably be best described as confused. The Romans left little mark. The Norsemen left names and fair-haired children. The Normans built castles; they allowed for and caused the development of the mainly agricultural South Pembrokeshire. Flemings followed the Normans and instituted trade. This grew and there was steady growth of sea trade up until the eighteenth century. Prior to this, Richard II and, before him, Henry II used Milford Haven as the launch pad for their armies to attack Ireland. The last of these attacks took place in the fourteenth century and it wasn't until the middle of the eighteenth century that, on the supposed enthusiasm of Lord Nelson, it was recommended to Parliament that Milford Haven be fortified. It seemed an excellent site for the necessary yards and docks to build ships for the Royal Navy. The subsequent development of Pembroke Royal Dockyard is well documented. The story is fairly convoluted but, in terms of the local population, important.

By 1864, the Tenby to Pembroke rail line reached Pembroke Dock, and was extended through the town to the dockyard. I have always believed that the extension of the railway into the dockyard was how Pater became known as Pembroke Dock. Could it be that goods reaching Pembroke had 'Dock' chalked on them to ensure their onward journey? The dockyard was, however, short lived, and closed in 1924. The RN maintained a presence and the RAF developed the site as a major seaplane base. The RAF base closed in 1957, followed by the closure of the RN base in 2000. Civilian developments took over the Haven. Oil refineries, a power station, liquified natural gas (LNG) terminals and replacement power stations have waxed and waned. There is now a Port Authority that has replaced the short-lived Conservancy Board. But a major and continuing factor in local development has been the Army. Unlike the RN and the RAF, it has been a constant. Initially, the Army occupied barracks at Llanion and the Defensible Barracks on Barrack Hill, before manning the defensive forts and gun towers around the Haven that were nicknamed 'Palmerston's Follies'. The Army presence extended to a great variety of regiments and corps serving and training in the region. It still has a presence in South Pembrokeshire, with training at Merrion and Manorbier respectively.

The positioning of the two gun towers by the dockyard is interesting. They have a clear line of fire along the dockyard wall. The dog-leg in the dockyard wall caused by the market building was covered by rifle slits. Above the town on Barrack Hill is the Defensible Barracks, a brooding presence that could be said to dominate the town. Was it fear of revolution or an overland invasion? It could have been either or both. The Defensible Barracks is a rare feature; there are only two in the world, the other being at Fort Worth in Texas. I'm sure

that the American version will not be allowed to decay. I hope that the crumbling in the 'Defensible' will continue to be arrested and that it will survive – my mother and father first met playing tennis on a court in the dry moat at the Defensible Barracks. He was in the Royal Artillery, she was a local girl. It was ever thus.

I would suggest that the story of Pembroke Dock has been critical to the major human, economic and physical changes that have helped to shape South Pembrokeshire. *Memories from Pembroke Dock* is an attempt to tell at least part of this story.

The idea of compiling an anthology or, more correctly a compendium of memories and tales handed down within families grew from talks and conversations at the Pembroke Probus Club. I tried to capture this once before, in the form of a magazine, but that crashed and burned. While I believe that the magazine was viable, a book is far more robust.

The concept of the book, once floated, appeared to generate a fair amount of interest. This enthusiasm was continued by a small group. There was no shortage of material. It is comparable to running across the face of a sand dune; the displacement of the first few grains of sand encourages the others, resulting in a mass of material flowing down the slope. This mass is varied in the shape and form of the material and the speed of its movement. There is an abundance of it, perhaps enough for a follow-up book.

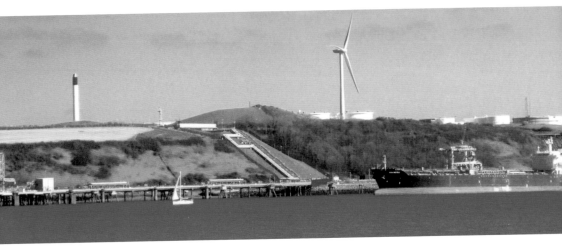

Gas and oil terminals complete with wind farm.

HMS Duke of Wellington (*below*) was launched in 1852. She was a first rate Ship of the Line. Designed for sale, she was fitted with screw propulsion. Paddle wheels were considered, but they would have reduced the power of her broadside by at least a third. The idea was discarded and screw propulsion was fitted.

For this she was lengthened by 9 metres for engine and boiler room and bunker space. At a displacement of 3,771 tons, she was the largest and most powerful warship in the world. She could make ten knots under power and sailed well.

Her significance to Pembroke Dockyard was that she marked the peak of the skills of the shipwrights in the dockyard and could be said to be a monument to shipwrights. The importance of the shipwright declined as iron and then steel became increasingly used in warship construction.

Some 162 years later, the activities in and around Pembroke Dock have undergone fundamental change. There is little marine construction today. Local industry has moved from warship construction to serving power generation and storage. Short sea ferries and cruise liners, farming, fishing and tourism complete the mix.

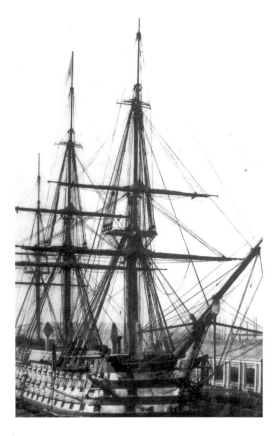

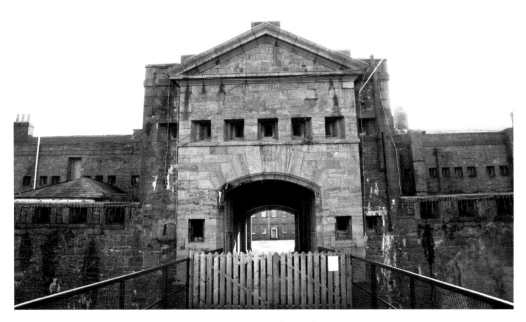

The Defensible Barracks on the Barrack Hill, viewed from Llanion.

Pembrokeshire's Haven:
an Introduction

David Ll. Jones and Joe Barnikel

The Haven of Pembrokeshire is an inland body of tidal water extending from its mouth in the Irish Sea and winding its way some 20 miles up the haven, with its numerous inlets and minor ports to Haverfordwest. There, its tidal waters meet the fresh river water of the Western Cleddau, and reach their navigable limits on the Eastern Cleddau at Blackpool Mill.

It was said, 'Given a fair wind and a good tide, a sailing vessel could get from Bristol to Milford Haven in two ebbs and back again in as many floods.' The sea was a trade route between Pembroke's 'Little England', the many ports of the Bristol Channel and well beyond. In pre-Roman times, the sea lanes linked many ports of Britain, Ireland and Brittany. The trade was in tools, weapons, pottery, tin, copper, and iron, which also added a cultural heritage.

In AD 877, Hubber, a Viking chieftain, wintered and sought shelter in the haven with a fleet of twenty-three ships and 2,000 warriors, It is reasonable to accept that the village of Hubberston originates from the Viking chieftain's association with the area. Pembrokeshire's Viking influence can be plainly determined in the names of its many townships and villages that are of Norse derivation, as are the islands of Grassholm, Gateholm, Skokholm and Skomer. The Vikings may not have conquered the region, but through trade and kindred blood ties they most certainly influenced the haven and its inhabitants.

Pembrokeshire's haven remained an inlet of minor ports through to the nineteenth century, but in 1814 a decision was taken that heralded the industrialisation of the waterway. A stretch of farmland on the estuary north-west from Pembroke was to be turned into a Royal Dockyard building warships for the Royal Navy. The following is an extract from the diary of Mr John Narberth of Pembroke:

> On the 14th day of May 1814, Mr Lowless and myself left poor old Pembroke to commence its rival, so on that day was the first shaving cut and first frame made by John Narberth, and by September 25th 1814, was the first four houses ready. Mr Thomas the foreman of Shipwrights wife came that day to take possession, and we drank to the success of the first house in Pater.

In those early days, Front Street was known as 'Thomas Street'. Mrs Lily Gaccon, who lived in No. 2 Front Street, directly opposite the 'Martello Tower', was a direct descendant of Mr Noakes, the assistant foreman responsible for building the tower, which is a wonderful example of the craftsmanship that existed long before modern-day aids and technology

existed. Sailing from Gillingham in the Medway, it is recorded that Mr Noakes and his family disembarked in Tenby and travelled by horse and cart to Pembroke Dock.

He and his five sons, who were all craftsmen, settled in the then-new town. I've often pondered over the fact that Mr Noakes and his family, along with their precious possessions, landed in Tenby and not somewhere in the haven. Another of the master builder's descendants is the Rt Revd George Noakes, a former bishop of St David'. It wasn't until 1837, with the completion of Telford Road, that the London Mail coach, having travelled from London via Gloucester, came to Pembroke Dock. In those early days before railways, and long before even the roads were suitable for stagecoaches, the 'main roads' of travel and commerce were by sea.

The Royal Dockyard built 260 ships, including five royal yachts, and was in its heyday the largest naval dockyard in the world. It was built on land farmed by a Mr White (the late Mr Vivian Hay of Pembroke Dock being a descendant of Farmer White). In 1918, the Royal Dockyard had a workforce approaching 4,000, which included over 500 women. In those early pre-motorised transport days, many dockyard workers rowed their way to the dockyard from way down and far up the river, battling against the tide, winter and summer, regardless of the weather. There were also those who would walk countless miles to work, many crossing the Pembroke River from the northern part of the county.

In 1853, a detachment of Royal Engineers was posted to Pembroke Dock. Under orders to examine and improve the Haven dockyard defences was a young Royal Engineer officer, who was later to become the renowned General Gordon of Khartoum. He lodged in Lewis Street and was but one of many thousands of servicemen who at one time served in our town. Nearly every English, Welsh, and Northern Irish infantry regiment has at some time

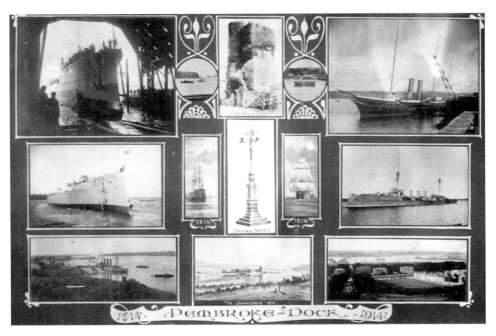

A 1914 postcard celebrating the centenary of the Royal Dockyard, Pembroke. (*Courtesy of George Lewis*)

served in Pembroke Dock, or 'PD', as our town was commonly known by the RAF flying boat crews. Some of the men were part of the town's garrison while, through the years, there were troops in transit to the Crimea, Africa, India and other parts of what was the British Empire.

Arthur Lowe, the well-known actor who played Capt. Mainwaring in Dad's Army, was another serving soldier who was stationed in the Defensible Barracks. Cumby Terrace was named after Capt. William Pryce Cumby, a veteran of Trafalgar who took command of the Bellerophon when his captain was killed, and then saved his ship by throwing an explosive charge overboard. He was appointed Capt. Supt. of the dockyard in succession to Capt. Sir Charles Bullock. He died in the first year of his appointment and was buried in Park Street cemetery.

South Pembrokeshire had too small a population to satisfy the needs of the yard. It meant that there was a major influx of working men and their families to the 'new town' of Pater Church, in order to work in the Royal Dockyard. They were mainly from the West Country, the South Wales Valleys and Ireland. This population was boosted in the mid-nineteenth century when two building yards, Deptford and Woolwich in London, were closed and the skilled workers were transferred to the Royal Dockyard. It is said and believed that this was the basis of the unique 'Pembroke Dock accent'. The town was thriving and by the latter part of the nineteenth century it had eighty-nine public houses, Front Street alone having seven.

The railway reached Pembroke Dock in 1864 and the Royal Dockyard was building composite iron and steel ships. However, this was little more than a nod to modernity

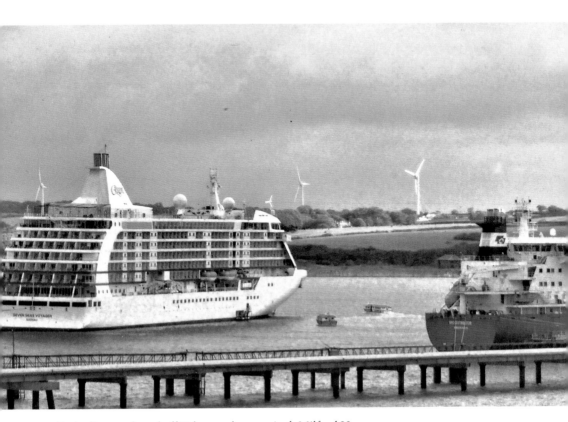

Cruise liner anchored off Valero tanker terminal, Milford Haven.

rather than a development. In spite of attempts at modernisation, the yard was limited by the number and size of 'fitting-out berths'. This limitation, plus the fact that the Admiralty perceived the North Sea to be the main area of operations, signalled the end. In 1921, the dockyard was considered surplus to requirements and was closed. The skilled labour force that had been built up was transferred or abandoned. In 1930, the bulk of the yard's buildings and slips were transferred to the RAF and Pembroke Dock became the largest seaplane base in the world during the Second World War.

After the Second World War, the military connections gradually disappeared, the Admiralty being the last to depart. Two private shipyards, Hayes and Hancocks, continued through the 1950s, but were both gone by the 1960s.

In the twenty-first century, Pembroke Dock has to reinvent itself. Shipbuilding has been revived by Mustang Marine, who are currently expanding their operations. The Milford Haven Port Authority is also planning to transfer it's dry-dock facilities from Milford to Pembroke Dock in order to service the haven's fleet of tugboats.

The Martello Marina project could transform the Pembroke Dock waterfront area. A marina with housing, a hotel, restaurants and a multiplex cinema has been proposed, using the outer marina wall as a cruise liner berth. This project has been mooted for some time but a recent development, for which planning permission has been sought by Marstons for a large restaurant on the old Jewson's site, could indicate the start of a new era for Pembroke Dock.

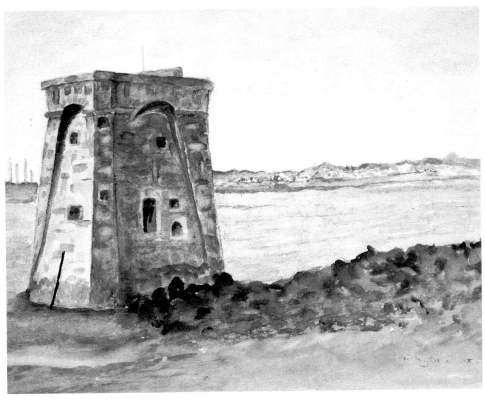

Watercolour of the Fort Road gun tower, by Phyllis Dix.

Ware Wire

Revd D. O. Calvin Thomas M.A. (Cantab.)

Youthful, unquestioning in pride of progress,
And vastly sure of man's wise technic skill,
His spirit gleeing in the cogs
And shafts and fine lathed cunning
Of production.
He visited the wire factory. Impressed
He returned, wide, wonder eyed
And carolled me with confident excitement,
Telling me of the smooth machines
On polished factory floor
Confident, supremely self-assured,
Their outreached, grasped aluminium ingots
With strength of steel, but with silken smoothness,
Fed them into their digesting bowels,
Then reached again for mounds of plastic,
And, with hot silent efficiency
Engulfed them, likewise, in their gastric brew;
Then, with no gasp of pain
Or strain of bringing forth,
Silent and effortless disgorged their end result
In one unending strand-
Wire of aluminium, plastic sheathed,
All calmly and with circumspect precision
Cozened in mighty rolls to serve the age,
To light a city, warm an ancient crone,
Or spew the jackpot from a one armed thief.
He spoke to me with enthusiasm,
You should have seen what I saw –
The smoothly, gracious efficiency of production.
Woe! That I've seen what here I see and now,
Walking a hillside overlooking Pembroke,
I see some graceless, distant, fretted towers
Fouling the line of sky,
Crude omens of a rearing desecration.

I wander on and soon I see
Long menacing and stooping low,
The uncoiled wire glint in the evening glare,
Its garrotting menace slung,
Noose like, from high pyloned sacrilege,
Malicious, sinister, impending,
Noose flung to choke the living beauty of an
Evening vale.
If only you could see what I once saw
But never shall again
for loveliness, that was, is littered now
Beneath a spirit's pain.

From *Anthology* by D.O. Calvin Thomas
M.A. (Cantab.) 1893–1983
Written during his life as Minister of the Gospel
in the Pastorates of the Presbyterian Church of Wales.
Published with the consent of his nephew, Wyn Calvin.

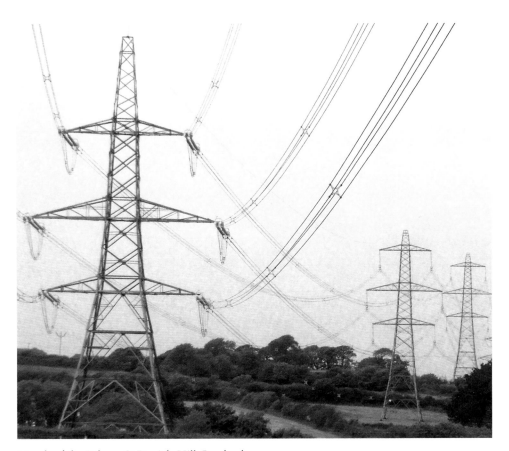

March of the Pylons, St Daniels Hill, Pembroke.

3

Pembroke Dock or What?

Ken MacCallum

Pembroke Dock should be famous and extolled in song. New York had only two names before Sinatra warbled on about it. If you count the anachronistic Doc Penfro, Pembroke Dock has had four names. I suppose that one could sing 'Pembroke Dock – they named it four times', but I think that even Sinatra would have stumbled with that line.

As a lad, my response to being asked, 'Where you from, "bay"?' would have been 'The Dock'. Unless I was asked by a local, then I would reply 'Llanreath'. Llanreath is possibly the Anglicised spelling and pronunciation of Llanrhydd, which can be translated from the Welsh as 'free enclosure'. This is somewhat unlikely, even though the village was so named in early documents from the Orielton Estate of Sir John Owen. More likely is the derivation of Llanreath from Llandraeth that is given by Mrs Peters, where Llandraeth translates as 'beach enclosure'. Reversion to the Welsh spelling would do little to change the pronunciation, as used by the locals, and would have a sound historical basis, unlike 'Doc Penfro'.

Warship building in the Haven was initiated by the Admiralty, who had rented a small shipbuilding yard at Milford. In 1809, negotiations were in hand for the Admiralty to purchase this yard in Milford when the owner, Mr Charles Greville, died before completion. The ownership passed to his sister-in-law, Louisa, Countess of Mansfield, who tried to 'gazump' the Admiralty and failed. The Admiralty then looked elsewhere for a suitable site for a shipbuilding yard in Milford Haven (the estuary and not the current name of the town).

Previously, in 1758, the Ordnance Department had bought a 20-acre site on which to build a fort. This was to the south of Paterchurch Point, from which the present-day Carr Jetty extends. The fort was never completed, but did house the Pater Battery of 32- and 64-pound muzzle-loading cannon. This battery used to carry out practice shoots at targets moored in Long Crane Bay. At low water springs, cannonballs can still be found on the mudflats in the bay. Subsequently, the site of the battery became a small tank farm and today it is a sewage treatment plant.

The Admiralty needed more space than offered by the battery, and bought another 40 acres from the Paterchurch estate of John Meyrick Esq. This land included a stream and cost the Admiralty £8,500 in 1814 (this is the equivalent of about £440,000 today a bargain). It is said that the name Paterchurch derives from the supposed church tower, still standing, inside the dockyard wall. This dates from the time of King Henry I and was built by the Knights Templar. However, other sources indicate that it was a thirteenth- century watchtower. Again, in the fifteenth century, it was claimed to have belonged to David de

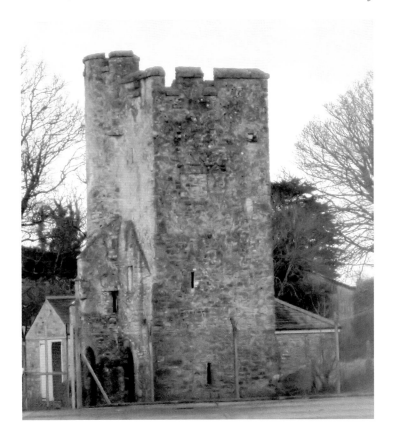

The Paterchurch
Tower inside the
dockyard wall,
Pembroke Dock.

Patrickchurch, a name subsequently corrupted to Paterchurch. While the origin of the name Paterchurch is the subject of debate, what is certain is that it was used both as the name of the Royal Dockyard and the town that serviced it.

Mrs Peters postulates an earlier name. In the late seventeenth century, the area had been referred to on an electoral roll as 'North Hook, within the Borough of Pembroke'. The borough of Pembroke had received its charter from King Henry I in 1109. There were three parishes in the borough: Monkton, St Mary and St Michael. The area that would become Pembroke Dock was in the Parish of St Mary. The year 1835 saw the Borough of Pembroke reconstructed into two wards, Pembroke and Pater. The Pater Ward became Pembroke Dock. The Pembroke Dock soccer team perpetuated the title of Pembroke Borough. However, to my knowledge, this title has never been used as the name of the town. By default, Paterchurch, subsequently abbreviated to Pater, was used.

Pembroke Dock is a 'new town'. Initially, the majority of the workers in the 'Yard' came from Milford. They sailed up to Llanreath and walked to work. The choice of Llanreath was controlled by the tides; H.W. Springs more or less coincided with start and finish times of the yard, and on Neaps they could always land on a shingle beach via Llanreath Lake. There was the added benefit of The Dolphin, a pub, close by. As the Yard expanded, other workers moved to Paterchurch from within the county. A great-great-grandfather of mine appeared on earlier censuses as fisherman, collier and lighterman of Llangwm. His son James started as a fisherman, then moved to Llanreath and worked in the Pater Dockyard. Better a 'dockyard matey' than hauling herring nets on cold January days! Additional workers came into the

Yard from all round the UK. They were either transferred from existing Royal Dockyards or formed part of the general movement of labour from agriculture to industry.

The town became a cosmopolitan mix that has given Pembroke Dock its unique character and accent today. There was a second wave of immigration with the influx of the military. This declined in the 1950s, although quite a few of the servicemen, such as my father, married local girls. Then there was oil, bringing in more folk 'from away', a number of whom stayed. Today, gas is having a similar effect, but this time the input is from the EU and not just the UK. Finally, there is the movement of people within the UK retiring and returning to Pembrokeshire. The population mix that started with Paterchurch is being maintained in Pembroke Dock. There was an early attempt to name the town 'Melvilletown', after the then-current First Sea Lord. This failed due to lack of public support, although Melville Place and Melville Road still exist in Pembroke Dock. Pater survived, if only because of popular usage.

Enter the Great Western Railway (GWR). By 1864, the rail line from London had been extended to what is now called Pembroke Dock. Goods shipped by rail were addressed to HM Dockyard Pembroke. It is said that the GWR employees at Pembroke chalked 'Dock' on the consigned goods. So it seems that, almost by default, Pembroke Dock was named by a railway porter and a stick of chalk. As I understand it, there has never been an official naming of Pembroke Dock. During the Second World War, it was nicknamed 'PD' by the local RAF and RAAF squadrons. This was possibly due to the signal flashed in Morse from the aero beacon in what we in Llanreath referred to as 'the Wireless Field'. The correct name was and is Patricks Hill, Llanreath, and not St Patricks Hill, as it is improperly labelled by a local developer.

There have been suggestions for a name change for Pembroke Dock in the recent past. Some elements have shed the 'Dock' of 'Pembroke Dock' in favour of 'Port' and 'Haven'. This does nothing but confuse. As for Doc Penfro, it has never been known as this by English or Welsh speakers. Paterchurch does have a history, unlike some of the modern upstarts.

I believe that if change is needed, the only one that should be countenanced is a return to Pater or Paterchurch. It is the name that was in common usage in the nineteenth century. For instance, on 20 December 1838, there is an entry in the logbook of the SS *Great Western* stating 'Dry docked Pater Yard'. Sounds fine to me, but then I could be biased. A family tradition has it that one of my great-great-grandfathers, son of a West Country innkeeper and smuggler, paid off the SS *Great Western*, possibly at Pater Yard. What is fact is that he did settle and farmed at Rock Farm, Llanstadwell.

Beware of needless change; at various times my old school, in Pembroke Dock, has been known as the 'Intermediate', 'County' and finally 'Grammar' school – then it was knocked down!

References

Guard, J. S., *H.M. Dockyard, Pembroke* (2004).

Peters, Stuart, *The History of Pembroke Dock* (1905).

Phillips, Lt-Col. Lawrie, *Pembroke Dockyard and the Old Navy. A Bicentennial History* (2014).

Phillips, Lt-Col. Lawrie, *A Short History of Pembroke Dockyard* (1993).

Phillips, Lt-Col. Lawrie, 'Pembroke Dockyard', Chapter VI in *Modern Pembrokeshire 1815–1974*, Vol. IV in Pembrokeshire County History (1993).

4

The Pembroke & Tenby Railway

George Lewis

The Pembroke & Tenby Railway is but a small piece of the Industrial Revolution, but nevertheless an example of enterprise, invention and determination, all qualities of that age of endeavour and progress in Great Britain.

Early in the nineteenth century, Pembrokeshire already had a railway (built in 1829 by the Saundersfoot Railway and Harbour Company) that would serve the various collieries and ironworks in the area. Horses pulled the first wagons of coal, but in 1874, sections became narrow gauge, allowing small locomotives to be used. This line declined in the late 1920s because of a fall in demand for its coal, but was revived again in 1932. It was eventually scrapped in the 1940s, its metal equipment used towards the war effort.

Although the South Wales Railway line took many years to complete, the construction of a railway running from Tenby to Pembroke suffered numerous delays. Prior to any progress with its development, Brunel produced a plan to build a railway from Whitland to Pembroke Dock, which was an important Royal Naval dockyard town with a growing population. However, this was to be situated well north of the eventual Pembroke–Tenby line, bypassing both Tenby and Pembroke on its route. This did not materialise, but a further line was considered, running to the Pembroke River from a branch off the original line at Nash, parting at Pembroke and going down each side of the river, with harbours constructed at East and West Pennar. This was approved by an Act of Parliament in 1853, but in 1855 the bill was thrown out because of difficulties with contractors, local landowners and the Admiralty. In 1858, the South Wales Railway produced a revised plan for a more level route. It involved a branch off the main line at Gelli, avoiding Narberth, Tenby and Pembroke, following the Eastern Cleddau down past Cannaston Bridge, Landshipping and Lawrenny, finally reaching Pembroke Dock via a series of bridges. This, again, was abandoned, mainly because of problems with landowners and the public, and due to the possible loss of revenue caused by missing population centres and commercial spots.

Because of all this shilly-shallying, certain individuals representing local businesses and agricultural interests, plus, in part, the Admiralty, decided to launch a company to finance and build their own line in South Pembrokeshire. This line, of course, would be totally detached from the main railways and would have a different gauge of 4 feet 8 inches to the broad gauge 7 feet 1/2 inches. Except for local labour movement and materials, it would be of only minor use to the dockyard. Local support was enthusiastic, but raising the £100,000 required for progress was not forthcoming and only £7,000 was raised. Fortunately, onto the scene came a major figure in railway construction and industrial activities in Wales, namely David Davies of Llandinam. Among other enterprises, he was building Barry Docks

for his mineral trading and large interest in coal mining and export. He offered to construct the line in return for a major shareholding in The P&T Railway, an offer eagerly accepted by board members.

Davies went into partnership with Ezra Roberts, another Welsh go-getter and prime industrialist, and with their drive things really got moving. The first section planned, from Tenby to Pembroke, was considered the easiest piece of track to lay; its route lay south of the Ridgeway and did not cross any major streams, so required few bridges or gated crossings to be built. The final section to Pembroke Dock would prove more difficult, with a major tunnel at Golden Hill and a need for numerous embankments, cuttings and bridges. Plans to eventually connect to Whitland, Carmarthen and beyond were scheduled for some time in the future. Mr J. S. Burke had been appointed engineer for the earlier plan that was set out by the board, and for which he had already surveyed and plotted the route. The Pembroke & Tenby Railway Act, passed in July 1859, had authorised the company to build 11 miles 35 chains of railroad between the two towns. Davies and Roberts pledged to build the line within the two years remaining from the time allowed by the Act.

The following reasons explain the choice by the P&T Railway to build in standard gauge rather than in broad gauge (which existed elsewhere in Pembrokeshire and beyond):

1) It was cheaper to build.

2) The board felt that eventually standard gauge would become the norm and in this they were proved right; the majority of railways converted to the system in 1872.

3) It was never planned to link the line with the SWR. Instead, it would find its own way to Carmarthen and beyond.

4) A line envisaged from Milford to the Midlands in 1862 would also be standard gauge.

There was a rival scheme by the Whitland, Narberth, Begelly and Pembroke Dock Railway also in existence at that time. Advocates were trying to gain support for a Parliamentary Bill but this had been rejected by Parliament and faded away once the P&T Railway got started.

On 22 September 1862, the schooner Pembroke beached at Tenby's South Beach with a large amount of construction items on board, such as rails, sleepers, ironwork, building materials and tools, which were hauled over the sand dunes by teams of horses to the site where work would begin. Tenby station, the starting point, was at that time situated in an old quarry south of the town and surrounded on three sides by high hills. This site would prove unsuitable when the line was eventually extended to Whitland and placed where the present station is situated.

The railway moved out rapidly across the sandy levels and westwards to Penally, the first stopping point on the new line. The 'navvies' (a corruption of the phrase 'inland navigators') building the line camped alongside it as they progressed, and some fine bridges were built over what were then mere Pembrokeshire lanes. They worked with vigour and purpose, supported by contractors' steam engines and locomotives with rolling stock along the way. The route was single-line throughout, with intermediate crossing places at each of the stations. Tenby became the headquarters of the company, but at that time only had one platform. It did have numerous sidings, a locomotive shed and a turntable, and in time a half-mile line was provided to Black Rock Quarry and the busy limekilns. Moving west, a number of intermediate stops and stations were built along the line: Penally, Lydstep Halt, Manorbier, Beavers Hill Halt, Lamphey and, finally, Pembroke.

The line opened to authorised traffic in July 1863, receiving a final inspection from the Board of Trade on 24 July. Prior to this, in May 1863, the first locomotive for use by the new railway had arrived, brought to Narberth Road by the SWR and then hauled by a team of thirty-three horses by road to Tenby. There they were greeted by a brass band and a crowd

estimated at 1,500, plus various dignitaries. The locomotive was immediately put into service and ran the entire length of the line on 12 June 1863. It pulled twelve trucks with a load of 600 people of all ages and stations in society. David Davies and Ezra Roberts stood at the fore in jubilant mood. Twelve further trains ran that day, packed with civic dignitaries and other excited passengers. At every vantage point, crowds of onlookers along the route waved enthusiastically at this new form of transport running through their countryside. Each 9.5-mile trip took thirty minutes. As a temporary measure, Davies and Roberts agreed to work the line on behalf of the company, who willingly accepted the offer made by these experienced gentlemen. Although the company now had their own locomotives and rolling stock, the first engine in service was named Llandinum and belonged to David Davies (named after his home in Mid Wales).

The newly founded Pembroke & Tenby Railway owned the steam engines Milford, Tenby, Stella, and Pembroke, and had rolling stock, goods wagons, carriages and brake wagons supplied by the Ashberry Carriage Company. The livery of the company is not firmly established, but is said to have been purple and brown, while the rolling stock varied. A stock list from 1896 lists purple and brown paint in large quantities, amber and black paint, red lead, white lead, Oxford Ochre, Japan Gold, and quantities of oak body varnish. Three passenger trains between Tenby and Pembroke were provided each day, with a scheduled running time of thirty minutes. From Pembroke station, a coach service ran to Hobbs Point in Pembroke Dock, where a ferry took passengers to New Milford so that they could travel to London via the SWR. Trains did not run on Sundays because Davies and Roberts had strong religious convictions.

The station at Pembroke lay on the eastern outskirts of the town, which was a source of grumbling for the tradesmen for a time. As the town grew eastwards, the complaints settled down. Despite the odd grievance, the railway prospered and over 40,000 passengers had made the journey by the end of 1863, along with numerous livestock, sundry goods and farm produce. Such traffic began to affect local shipping and haulage businesses and would do much more in the future, with the extension of the railroad to Pembroke Dock and the Royal Dockyard, and its final link in to the nationwide network.

The Rail Extension to Pembroke Dock

Work began almost immediately on the extension of the line to Pembroke Dock, with a route curving west along an embankment and over three bridges before entering a short cutting. This led to Golden Hill, through a 460-yard tunnel and over a further bridge to Llanion Halt, before eventually reaching the station at Pembroke Dock. The work, despite all the physical effort and problems, was completed in July 1864. At one point, a moment of elation was recorded on New Year's Eve 1864; Ezra Roberts crawled through a small hole on the Pembroke Dock side of the tunnel and emerged at Golden Hill.

Because the company intended to extend the line to some point on the waterway, with a view in the future to establish shipping contracts to Ireland and other destinations, they planned the original site of Pembroke Dock station at Hobbs Point. Because of the difficulties in obtaining what was then Government Land, they built a temporary station at the eastern end of King William Street. This delay and later consideration finally led to the station being built nearer to the town at the eastern end of Dimond Street. This station was opened in 1865.

On 9 August 1864, however, the inaugural train arrived in heavy rain at the temporary Pembroke Dock station. On that day, every item of rolling stock was pressed into service to cope with the demand on that festive day. A band led a procession to the Victoria Hotel

The name of the Pembroke & Tenby Railway survives on one of the portals of the 460-yard Golden Hill tunnel, west of Pembroke. (*Courtesy of George Lewis*)

at the junction of Pembroke Street and Queen Victoria Road, where a grand reception took place at which the chairman of the GWR was present. He was in the locality for the opening of the Milford Docks Railway. The daily service of the P&T Railway had now increased to four trains a day each way, with an overall running time of 35–40 minutes each way. Passenger traffic increased to 145 journeys in the year ending in June 1865.

Problems still arose. The Post Office, at that time operating from Pier Road at Pembroke Dock, did not give P&T extra revenue to provide mail trains. Furthermore, the residents of Pembroke complained of the narrowness of the road bridge at East End and the distance of the railway station from the main town. David Davies, following their suggestions, temporarily put a station at Golden Hill Halt.

In time, a connection from Tenby to Whitland was planned by an Act of Parliament in 1864 and Davies and Roberts agreed to build it for a sum of £200,000, despite an early disagreement with the P&T board. Requiring sizeable earthworks and masonry structures, the construction of this 16.5-mile line to Whitland proved a much harder task than the Pembroke to Tenby line. Tenby's original station was moved from its quarry site via an embankment to its present position. Beyond the station to the west a fine, seven-arched viaduct was built wide enough for double, track working. From Tenby, via gradients, cuttings, bridges and embankments, it went on up to Whitland. Stations were established at Saundersfoot, Kilgetty, Templeton and Narberth, a number of which, like Pembroke, were placed well outside the areas of habitation (especially in the case of Saundersfoot). Connections were made to the busy collieries at Moreton and Boneville Court for the transportation of coal. A connection was also made to the Saundersfoot Railway network. The original P&T stations were improved, with the production of fine stone buildings, with canopies and extended platforms in some cases.

A line was finally extended through to the Royal Dockyard, where the Admiralty's own engine took over to move the various wagons around the Yard. This line was completed in 1871, with an Act of Parliament in 1866 stipulating that it was only to be used for dockyard supplies, personnel, naval staff, coal, wood, steel and all provisions for a modern

Victorian Navy. This line to the dockyard required four gated crossings within the town. The Hobbs Point extension went on swiftly, with an Army loading platform and suitable siding provided for military supplies for use by the garrison town. The Armed Forces themselves constructed a large ordnance depot on Pier Road.

As with Pembroke and Tenby, goods yards were in place, with adequate sidings for the loading and unloading of the many varied goods such as timber, coal, agricultural items, livestock, regimental equipment and fuel. Various sidings were, in time, placed at stations such as Lamphey for local goods wagons and livestock wagons.

In 1867 the P&T secured the General Post Office contracts. The connection to Whitland was completed in 1869. In time, a connection was made to Carmarthen and beyond, and shortly afterwards the wishes of the P&T board from the onset of the railway came about when standard gauge became the norm on all British railways.

The established Pembroke & Tenby Railway was not, however, all that financially successful and in 1897 was finally incorporated with the GWR, which immediately renewed the entire trackway and made a number of improvements to the stations and facilities along the entire line. At Pembroke Dock, in particular, a canopy was built over the down platform, while the north platform was extended and a shelter built over the original part. The existing engine shed was enlarged with greater repair facilities and a 55-foot turntable was built. This allowed engines to be turned for the return journey Up line. Extra sidings were added and the existing signal box was replaced with a much improved model. Finally, a weighbridge and parcels office was installed on the south platform.

Pembroke & Tenby Railway boundary marker, Water Street, Pembroke Dock. (*Courtesy of George Lewis*)

The Castlemartin Tank Range

John Russell

The first hint of any planned requisition of land for a tank training range was in 1936, when the RAF used 100 acres of Flimston Farm to establish a tented camp and airstrip. This was support for planes to fly and tow targets for the Anti-Aircraft Artillery training camp based at Skrinkle Head, near Manorbier.

The actual requisition for the tank training range came in 1939 from the War Office. It served requisition notices to fifteen farm homesteads to be vacated by 29 September 1939. It was, however, in 1938 that an unannounced War Office land agent informed Lord Cawdor that lands forming part of his Stackpole estate were to be requisitioned. In total, this would be some 6,000 acres. The original proposal for the range extended eastwards from Freshwater West to include some of the south side of Castlemartin village. It extended (through Chapel Farm, the West Farm buildings, Moor Cottages, Warren School and Nurse's Cottage, excluding Warren Church) through to Holcons Lane. It then stretched south to the B4319 (the Stackpole, Brownslade Road) and east to Lyserry farmyard, before finally heading south to Carew Farm, Bosherston and the coast at Newton Farm. A later plan excluded Treforce, Loveston Farm, Lyserry Farm and Carew Farmhouse and buildings.

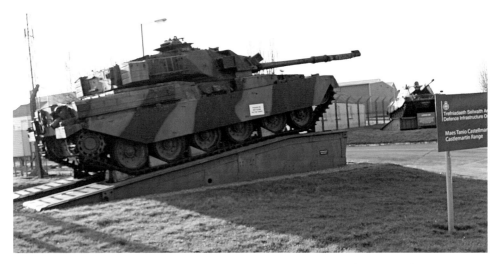

The Gate Guardian, a Chieftain tank, at the entrance to the Royal Armoured Corps Range, Merrion.

Many objections were raised to this proposal, especially from the parish councils of Castlemartin and Warren, plus the Pembroke Rural District Council. Even then, the War Office Cabinet, chaired by the then Prime Minister, Mr Neville Chamberlain, did not get wholehearted support for the range, which had been proposed by the Secretary of State for War, Mr Leslie Hore-Belisha. The Minister of Agriculture professed that this requisition was taking the most productive land in Wales. The Secretary of State for Foreign Affairs thought that there must be land elsewhere. He could not understand why the taking of well drained level land was necessary for tanks, which operate over rough ground. During the 1940s, British tank crews were trained to fire the main gun of the tank on the move. It meant that the gunner, by flexing his knees, counteracted the pitching movement of the tank. He effectively became a crude form of 'gyro stabiliser'. Over rough terrain, the tank would come to a halt before firing.

The Chancellor of the Exchequer, Sir John Simon, stated that he had personal knowledge of the area. He considered it to be a beautiful and unspoilt landscape that would be ruined. It is interesting to observe a seaward view of the coastline that includes the western boundary of the tank range. To the west of the boundary, there is considerable degradation of the dunes. This appears to be the manmade result of erosion and fire. To the east, in the area of the Pole and Frainslake, there appears to be little or no damage.

Undoubtedly, the War Office approved the Castlemartin range for its locality and coastal boundary, and for the fact that it was in the ownership of one landlord. The coastal boundary was important in that it allowed for a relatively free fire zone seaward that was effectively policed by range safety launches.

Eventually, following the hearing of all these objections, the villages and farms were excluded from the range area. Requisition was approved for the fifteen farm homesteads, totalling 4,366 acres, and the periphery land of 1,391 acres; the total land mass was 5,757 acres. As you may gather, this requisition was of great local concern to the farming families losing their farms and homes, the majority of which were of many years standing. In addition, there was the effect on the farming trade in Pembroke; it caused a reduction in the size of the local livestock market and affected the farmers' wives, who produced butter and marketed it together with eggs and poultry to the local shops. In turn, they purchased their weekly requirements for the home. The majority of the farmers, after having to surrender their tenancy on the Stackpole estate, found other holdings in Pembrokeshire.

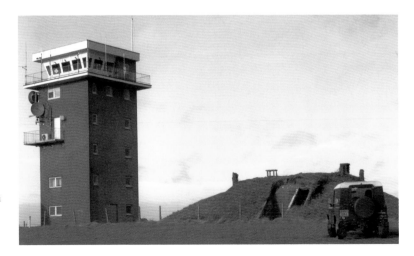

An observation tower on the Merrion tank ranges.

Details of the Land Taken for the Tank Range

Starting from the east, there are fifteen whole farms and part farm holdings on the boundary of the tank range.

No.	NAME	ACRES	FARMER
1.	Bucks Pool	322.5	T. C. Murray. [The son, Billy, taking Crabhull and then Eastington Rhoscrowther]
2.	Crickmail	324.0	E. A. Brace. [North Studdock, Angle. Prior to buying Goldborough, Hundleton]
3.	Newton Bosherston	103.25	J. Thomas. [Trecwn, Letterson]
4.	Trenorgan	290.8	J. Richards & Son. [Fern Hill, Haverfordwest]
5.	Hayston	244.5	J. Scale. [Walwyns Castle, Haverfordwest]
6.	Longstone	392.5	Eric Roch. [The Fields. Maidenwells]
7.	Ermingate	72.5	Robin Davies. [Llandilo}
8.	Flimston	491.0	T. Thomas. [East Orielton Farm]
9.	Mount Sion	292.0	T. Brace. [West Pennar-Kinsfold]
10.	Pricaston	268.0	Geo. Thomas. {Northdown-Lamphey]
11.	Bullibar	460.0	Miss Thomas.
12.	Pen-y-Holt	390.0	J. Esmond. Ash Hay, Castlemartin.]
13.	Linney	501.5	H. B. Davies. [Crickmarren.[[The son, Spencer taking the Grove, Jameston]
14.	Brodslade	204.6	Alan Colley. [Farm]. Fred Paical. [House]
15.	Frayns Mill	8.0	Jack Rees. [Cosheston.]
	Total Acreage	**4,366.15**	

6

Farming in South Pembrokeshire During the 1940s

George Mathias

It is impossible to write about farming in South Pembrokeshire during the 1940s without first considering the ownership of the farms by the large estates. The county council also played a significant role when they started to purchase agricultural land in the mid-1920s. They split up the large units into smaller farms, which were rented out. An example of this is Castleton Farm, which was divided into four holdings. There were far more owner-occupied farms in the north of the county.

Farming was in a sad state in Pembrokeshire in the 1930s. The Milk Marketing Board (MMB) and the Potato Marketing Board (PMB) were established in 1933 and 1936. The MMB had far greater powers than the PMB. At its peak, around twenty-five years ago, potato farming accounted for about 12,000 acres. Now, it is more like 2,000 acres or fewer, mainly due to cheaper imports.

In 1934, the chairman of the Pembrokeshire branch of the National Farmers' Union was L. M. Russell. In 1932, there were only eighteen branches. The landlords had difficulty in finding tenants. Consequently, inducements such as providing basic slag and lime to use on the farm were offered.

Farming was depressed; there was no local population and nowhere nearby to act as a market. The introduction of the MMB enabled farms and farming to become more attractive. In addition, in the late 1930s, a large amount of land was requisitioned by the War Department (now the MOD) for use by the Army and RAF. The establishments at Manorbier and Castlemartin exist today, while others, such as the aerodromes at Carew, Templeton and Angle, have returned to farming. The tenant farmers had to leave. If they were fortunate, they obtained tenancies on other estates, but many farmers lost their livings. All compensation went to the landlord. Under the Chreale Down Procedure at the end of the war, the land was deregulated and offered back.

But we are getting ahead of ourselves. The government was aware of the threat of war. It realised that the UK could not depend on the 'Empire' to feed a population of 40 million. It soon became apparent that the prevailing condition of British agriculture could not feed the population. There was little or no farm machinery, and the land and livestock were in poor condition. This was the result of existing market forces. At that time, it could be said that the farm was worked with 'a dog and a stick'.

At the start of the Second World War, the knowledge and skills required for intensive farming did not exist. There were no market forces to drive them on, and farmers did not have the scientific knowledge to bring about change. Farming methods were those passed down from father to son – the economics did not encourage or allow for anything else. As

'Dog and stick farming'. (*Courtesy of John Russell*)

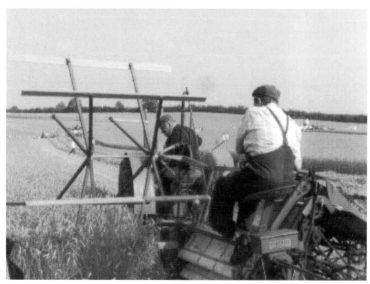

Reaper and binder, more usually horse-drawn at this time. (*Courtesy of John Poyser*)

the economic situation improved, so did farming techniques. The answer to the question of how farmers coped with the war is hard work and the ingenuity of the true countryman.

The Pembrokeshire War Agriculture & Executive Committee (PWAEC), composed of farmers, had extensive powers. This caused ill feeling with the farmers not willing to plough pasture, which was now compulsory. Indeed, some farmers were overruled and dismissed for bad husbandry when new crops, such as flax and sugar beet, were required to be sown to assist the war effort. This often happened in spite of the terms of the tenancy that defined what the farmer could or could not plough.

As the war progressed, PWAEC progressively gained more powers and provided help to the struggling farming industry. Land girls made their appearance. Hostels were built and some large houses were converted to house them. The government bought machinery and set up depots from which machinery could be hired, sometimes with operators. POWs were drafted in as labour. A lot of derelict land was reclaimed, such as parts of the Pembrokeshire coalfield and Castlemartin Course. One tale tells of Lord Hudson, Minister of Agriculture, who was approached by a local farmer when on a visit to Pembrokeshire. The farmer said, 'Give us the tools and we will do the job', to which the minister responded, 'Your machines are at the bottom of the Atlantic, you'll still do the job.'

There was not a lot of recreational activity, only socials in the village hall and chapel. Pubs had little alcohol. There were few cars, and petrol rationing made sure that there was little driving. In the early part of the Second World War, the pressure on farmers to feed the nation was tremendous. The use of British Double Summer Time extended the working day, and farm workers who had not been conscripted had Home Guard duties, which were occasionally extended. An exercise involving paratroopers trying to capture the dockyard at Pembroke Dock was intercepted by a group of Home Guard at St Florence. The Home Guard were captured, had the bolts removed from their rifles and had to collect them from Lamphey School, all before milking time.

As the war progressed and machinery started to become available, farmers made applications for various items. These were often shared between farms, and a tremendous amount of work was done. For example, the Ridgeway between Wheel About and Hogeston Hill was all fern. It was ploughed and reclaimed, and became a major area for growing new potatoes. This area was also notable for rabbits that were trapped before being hung in rows of baskets along the platform at Manorbier station. Prior to myxomatosis, there were sufficient rabbits to maintain a 'rabbit factory' in Pembroke.

The government was the sole buyer of farm produce; prices were set and all stock graded. At the livestock markets, there was a government grader to ensure that grades and prices

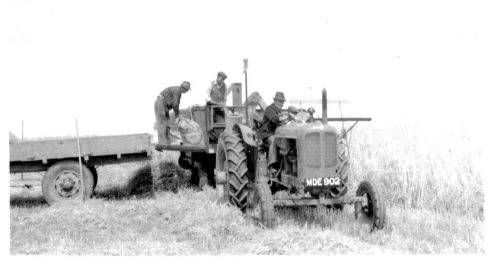

An early reaper/thresher, a step on the way to a modern combine harvester. (*Courtesy of John Russell*)

were rigidly controlled. This system, which remained in place even after the 1947 Farming Act, was good for farmers in that it gave them security of tenure and a guaranteed market for their produce. At this time it was not uncommon to see cattle leaving Pembroke Market by train for slaughter in the Valleys.

Knowledge continued to improve after the Second World War, particularly concerning the quality of stock. This received a major boost from artificial insemination and the means to transport livestock greater distances. A major factor in the improvement of knowledge was the Young Farmers Club. The local branch was founded not as a social club but as a means of education. This was achieved by having speakers who were experts in their field. New crop varieties were developed, particularly at the plant breeding station run by Professor George Stabledon at University College, Aberystwyth. Pembrokeshire farmers owe a lot to the work done here in producing new varieties of grass and cereals, particularly rye grass.

Similar work was applied to improving stock. Friesians and Herefords were introduced, replacing the cross-breeds. This even caused the Castlemartin Black to be derided; in the 1930s they were dismissed as 'only fit to pull a plough'. Likewise with sheep, the Down breeds became popular. One story relates how two farmers drove to Craven Arms, bought a pair of rams and drove them back to Pembrokeshire on the back seat of the car. It wouldn't be done in the Lexus or Mercedes of today!

A major improvement initiated during the war years was the testing of cattle for tuberculosis. A voluntary scheme for testing, started in 1942, became compulsory by the early 1950s when the disease was eradicated. The 1960s saw the Animal Welfare Act when tuberculosis returned. Cause and cure are hotly debated outside the scope of this piece.

The years between 1945–47 saw major developments. The Ferguson tractor introduced the strong arm of hydraulics to the farm. Electrification allowed greater development of milking parlours, and water could be pumped. The yield of potatoes and barley was increased due to advice from within the industry. In fact, the war revolutionised agriculture and the process continues to this day.

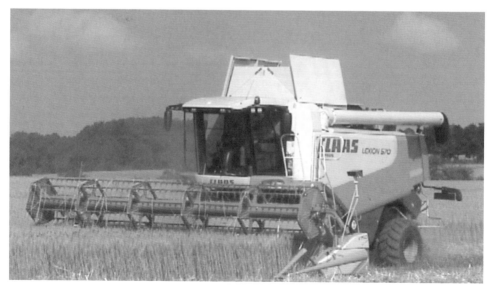

A modern combine harvester. (*Courtesy of Hinrich*)

A Young Girl on the Farm

Monica Vanner née Harris

I was born at Vallen Farm, Lawrenny, on 1 October 1941. My parents named me Monica Ann Mathias Harris. After farming at Vallen Farm for thirteen years, my parents moved, when I was three years old, to Wallaston, a larger farm with better land.

The move from Vallen to Wallaston was a very big undertaking in those days and could be compared to a Western Cattle Drive. The cows had to be milked before setting out on the long journey and all the neighbouring farmers came along to help out. My father had eighteen cows and twenty-five cattle. A horse and cart headed the procession and a further horse and cart brought up the rear. The carts were full of pigs and young calves. The procession managed to get to Wallaston in time for milking, although they lost two cattle on the way. These were found two weeks later at Mutton Hill, just outside Pembroke, and were kept safe until someone was able to collect them.

I loved to hear the story about our big move and would have loved to have taken part. Alas I was far too young and, along with my younger brother and sister, went to stay with my Aunt Rene while all this was going on. It must have been a wonderful sight, especially going through the main street of Pembroke, and would not be allowed today. Of course, cattle lorries are now used to transport livestock.

When I was five years old, I started at Pwllcrochan School, which sadly is now closed. The school was 1.5 miles from home and we all walked there, always running the last 500 yards with the sound of the school bell ringing in our ears. The only time we didn't walk was when it rained heavily, and then my father collected us and the other children who lived in Wallaston Green. Quite often, as many as seven or eight of us children piled into his car. No health and safety to worry us in those days.

After school we all had different jobs to do. We dared not complain and just got on with them. My first jobs were to bring in the logs and pump the water into a tank for our domestic use from a reservoir in one of the fields. We all took turns pumping for ten minutes at a time, and we all hated this job. As I got older, I was allowed to prepare the Tilley lamps, which my father carried out to the milking parlour. This involved making sure each lamp was full of paraffin and the glass globes were clean. We had a posh lamp for our living room, with a white mantle, that turned red once it was lit.

I also had to help with the milking along with my brother, Tudor. There was no electricity until the 1950s so my father bought a generator, which enabled us to run the milking parlour. The generator operated the machine, which enabled the milk to travel from the cows to a cooling shed, then into the churns. There were two lights that ran off the generator, one for the milking parlour and one for the kitchen, but, best of all, it ran a television – our

Above: Pwllcrochan School front and back, alas no longer used.

Left: Milk maids Monica and Olwyn. (*Courtesy of Monica Vanner*)

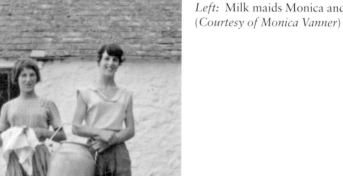

very first black-and-white set. When the Queen celebrated her Coronation, many people from the village piled into our sitting room to watch, as we were the only family to have a television.

Life on the farm was never boring – there was always something going on, for example lambing. Sometimes we had 'Molly' lambs, which had to be bottle-fed. Shearing was a big day. I used to help roll the fleeces – a very greasy job in those days. Before shearing took place, the sheep had to be taken to Wallaston Farm to be washed in a large lake. Farmers from around the area went there on the sheep-washing day. Later on in the summer, the

farmers dipped the sheep. The sheep were dipped to stop flies landing on them, which could cause maggots to appear at their rear end. All the local farmers did this together in one place, helping each other. This occurred at Wallaston Farm, where there was an old mill and pond with a huge wooden wheel that drove the water into the man-made dip. All the children loved this day as many of the local farmers gave us sweets – what a treat!

Threshing day was another big thing in the farming fraternity, but it was not my favourite time because of the dust and chaff that used to stick in our clothes. The best part was when we had to lead our two carthorses, Duke and Bright, home. Duke had a dark coat and Bright was light grey. Horses were used to help with the process of threshing.

During the time of threshing, neighbouring farmers always sent someone to help. My mother used to feed these men a full roast lunch or boiled ham, parsley sauce and pudding. There were frequently about twelve to fourteen men, and I helped to serve at the table and afterwards with the washing up, when I had to stand on an upturned saucepan in order to reach the sink. Everyone enjoyed the day.

Coming from a large family, we had to make our own fun but there was always someone to play with. In winter we played card games, draughts, and tiddlywinks, but it was the summer we enjoyed most, playing outside until it went dark. We played cricket, football (it seemed I was always in goal) and rounders. We also played imaginary games, such as winning the Grand National. We used upturned milk churns, and would all be in a straight line with a little stick banging and hitting the churns, which of course never moved. I was always Dick Francis, my brother was Fred Winter and our saddle and reins were baler twine tied to the handle of the churn. We used to take it in turns to win.

There was a pond on the Green, 200 yards from the farmhouse. We had so much fun on this, making rafts that always sank. My mother once gave me her old galvanised washing tub, which made a good boat, but we ended up in the water so many times and had to strip down to our underwear in order to play in the pond. We then ran around until we dried off. I don't ever remember our mother telling us off for getting wet.

Despite living near the beach, we didn't often go there as children, but as I got older, nine or ten years old, my sister Olwen and I used to ride our bicycles to Angle Beach. We didn't have wristwatches but always knew when it was time to go home. We spent more time getting to and coming home from the beach than actually on the beach. My mother had knitted our swimming costumes and we were reluctant to take them off when wet, as they sagged and hung down past our knees. Happy days, eh!

The annual Pembroke Fair, held from Saturday to the following Saturday, was a big event in our lives. My father gave us a shilling each and we never asked for more (as we knew the answer), but we did try to meet some of the older farmers and their wives, who went to the fair. Being polite, with a big smile, frequently earned us the gift of sixpence or, if we were lucky, a shilling. We thought we were in heaven.

My father's farm was a mixed one. There were cows, sheep and pigs and we also grew corn, wheat, barley and early potatoes. I used to help to weigh the potatoes on special scales. I did not pick them often as my father used to employ pickers from Pembroke Dock. He collected up to sixteen pickers in his lorry. The younger children, even babies in prams, also came. The year I passed my driving test, my father said I was to drive the pickers home in his lorry. I was so nervous but I didn't dare argue. To my relief, at the last minute, he said he would come too.

I must have driven quite well because my father allowed me to do it many times after that. Despite all the extra work that had to be carried out on the farm during the summer months, the cows always had to be milked. I was about fourteen years old when my father

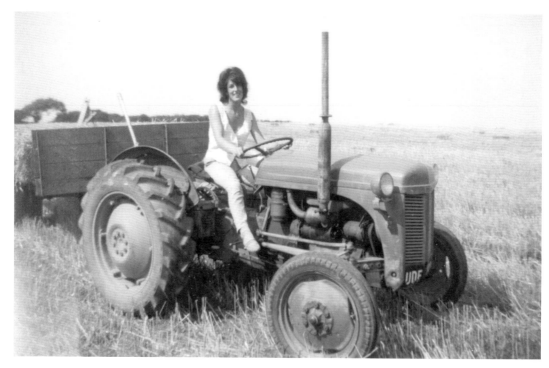

Monica and her little Fergie. (*Courtesy of Monica Vanner*)

Twenty-first-century potato picking. (*Courtesy of Margaret Phillips*)

asked me to get the cows and tie them up ready for milking by my elder brothers. I decided to try to do the milking by myself, having helped many times before. My father walked into the cow shed and was really surprised. I had nearly finished, except for two cows, which I didn't touch as they were 'kickers'. My father finished off by putting teats on these and I carried on with cooling the milk. I felt I was on cloud nine and so proud of myself. My father must have been pleased too, because he gave me a £5 note – a lot of money in those days. It was the first of many times that I milked the cows on my own.

Each Saturday evening, my job was to clean all the shoes belonging to my father, brothers and sisters, in order to be ready for church the next day. Some of us went to the 10 a.m. service and the rest to the 11 a.m. service. In the afternoon the younger ones went to Sunday school. We all walked to Rhoscrowther church, where there were three classes, mixed little ones, one for girls and one for the boys. After Sunday school in the summer, weather permitting, we used to play rounders which was great fun.

Summertime was 'show time', when we attended all the local shows like Pembroke, Martletwy and the County Show held at Haverfordwest. Most years, show time meant a new dress for me. As a little girl, I remember the dresses being pretty, always smocked tops worn with white socks and Kiltie sandals. In my teens, I wore dresses with two or three petticoats to make the skirt stick out and with my little white handbag. I felt so posh!

Joining the Young Farmers Club (YFC) at the age of fourteen was the highlight of my social life. I was a member right up to the day that I got married. Meetings were held every Friday evening, usually at the old Lamphey Village Hall.

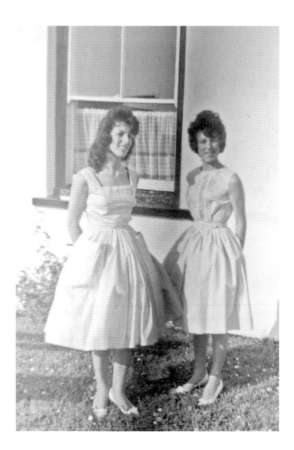

Monica and Olwyn. (*Courtesy of Monica Vanner*)

In 1961, Pembrokeshire won the Proficiency Badges Cup. We competed against all the YFCs throughout Wales. The award was similar to today's Duke of Edinburgh Award and was achieved over a nine to twelve-month period. We were all very proud to travel to London to receive the award, which consisted of a cup and certificate, from the Duke of Edinburgh. Travelling to London was a big thing at that time, as most of us had not been further than Carmarthen. We had an exciting few days in London, sightseeing and travelling on the Underground for the very first time.

The club was involved in inter-club events with other clubs around Pembrokeshire. This gave us the opportunity to meet farmers' sons and daughters from all around Pembrokeshire. The big event in the calendar of the YFC was the rally. All clubs took part in various competitions, including folk dancing, cattle judging, sheep shearing and tug-of-war. Prior to the day of the competitions, there were drama and public speaking competitions, which, if you were good enough, attracted points for a shield. The club with the most points at the end of Rally Day was judged the winner. Pembroke YFC won the shield a few times.

In the lead up to Rally Day there was a Rally Queen Dance, where a queen and four rally attendants were chosen. These were not chosen because of their looks but because of their achievements during the past year within the YFCA movement. In 1963, I was very proud to be chosen as a rally attendant. I still have the rose-pink dress I wore on the day.

Anyone who won a competition at the rally went on to represent Pembrokeshire at the Royal Welsh Show and also at the Royal Dairy Show at the Olympic, London. I won the chicken trussing competition for under 21s and went to the Royal Welsh Show, Builth Wells and also the Royal Dairy Show. All expenses were paid for four nights in London. What a time we all had. I finished third overall and was very pleased, as there were about thirty to thirty-five taking part.

Being brought up on a farm is the best life anyone could have. It is hard work but we also played hard too. I had wonderful parents and the memories of my childhood and teenage years are something I will always treasure.

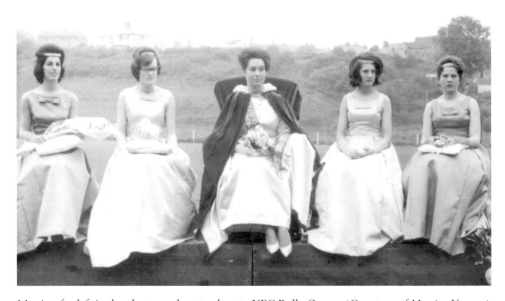

Monica, far left in the photograph, attendant to YFC Rally Queen. (*Courtesy of Monica Vanner*)

My Memories of the Second World War in Llanreath

Leonard Ambrose

I would like to tell of my experiences during the Second World War in Llanreath. Local people inevitably remember the bombing of the oil tanks at Llanreath/Pennar. However, there was a lot more involved. You will read of connections and interconnections of time, people and places. Many different tales will combine to form the whole story.

Please understand and accept any errors. They are all mine – it is just a case of a fading memory.

On the afternoon of Monday 19 August 1940, three Junkers 88 aircraft carried out an attack on the oil tanks. At the time, I was six years old and with a gang of boys from Llanreath. We were on the south-east facing shore of Pennar Gut, below what is now known as Pennar Park. There was a small slipway there and we were all sitting about on the rocks. It was a beautiful day.

My attention was drawn to a plane to the east, which was circling over Hundleton with another two planes. I was curious as they were different from the Sunderlands at the local RAF base, which I saw every day. As these planes got closer, I could see their markings and I shouted out, 'They're Germans!' A little later, bombs were exploding and the machine guns on the plane were firing in order to ignite the oil.

Sheer terror gripped the group of us. We all started to run for home at Llanreath, though in no time at all we were flat out. Common sense and logic had gone straight out of the window. Having reached the trees on the north shore, we could have slowed down, stopped and walked. But no, the adrenaline, fuelled by terror, was in full flow. Coming to the end of the woods, with a beach called 'the Diggins' a couple of hundred yards away, I launched myself feet first down the cliff. It was a senseless thing to do. But I bounced like a rubber ball and hit the beach running. I paid no attention to the 'Llanreath Lion'. All I wanted was to get home.

At this time, I was living in 'Beach House' at the bottom of Beach Road. It was the only one on the terrace with a side entrance and passageway the width of the house. My grandfather, Sidney John, was a shipwright. He had the foresight to reinforce the sides and roof of the complete passageway. He had also fitted seats down one side. I took the bottom part of Beach Road like a greyhound. I reached home, where the passageway was full of people. My mother came out and I collapsed into her arms. Later in life, when people spoke of Emil Zapotek and Roger Bannister and how fast they could run, I'd smile and say 'not bad'.

The tanks were ablaze. The oil had overflowed from the moat, round the tanks, and run down the slope of the valley behind Llanreath, into the small stream at the bottom. This flood of oil came out on to the beach at Llanreath. I looked at this in disbelief – all our lives

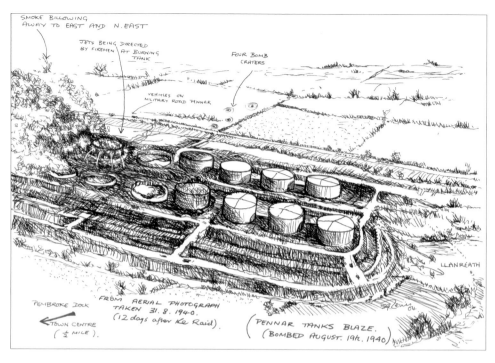

SMOKE BILLOWING AWAY TO EAST AND N.EAST

JETS BEING DIRECTED BY FIREMEN AT BURNING TANK

FOUR BOMB CRATERS

VEHICLES ON MILITARY ROAD PENNAR

LLANREATH

PEMBROKE DOCK
←TOWN CENTRE (¼ MILE).

FROM AERIAL PHOTOGRAPH TAKEN 31.8.1940.
(12 days after Ke Raid).

PENNAR TANKS BLAZE.
(BOMBED AUGUST. 19th. 1940)

G. Lewis 04

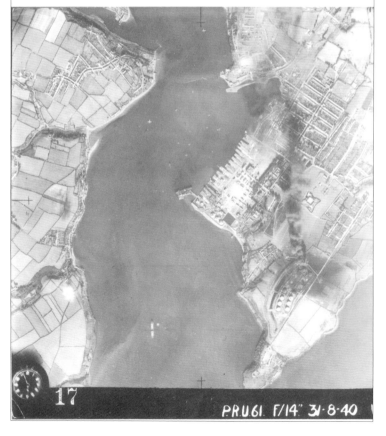

17 P.R.U.61. F/14" 31·8·40

Above: Panorama of the air attack on the Admiralty oil tanks at Llanreath. (*Courtesy of George Lewis*)

Left: Vertical air photograph of the Admiralty oil tanks, 8 July 1946. (*Welsh Government*)

were linked to boating, swimming and fishing. I wondered if everything was ever going to be the same again. We had to pack and leave Llanreath, finishing up at No. 53 High Street with my aunt, Eva Davies.

Due to the prevailing westerly winds, the stench and smoke from the burning oil was horrendous. The task of the firefighters was almost impossible using just water. Some, from Cardiff, lost their lives. These were desperate times. At the time of the air raid, Gerald Donovan and Jim Griffiths were working in No. 1 tank bund. They had the ambivalent experience of a good view of the attack as it took place, and sought safety in the tunnel that connected the tank farm to the dockyard. The tunnel passes underneath the Barrack Hill.

After all the fires were out, we returned to Llanreath, this time to Beach Cottage. One Sunday night we were having supper when the air-raid siren went off. We left the table and moved into the small entrance hall behind the front hall. There was a huge explosion and a flash. The front door flew open and all the lath and plaster in the living room came crashing down. What a mess! And what a loss – all the spuds, pickles and meat kept in the pantry were buried. The bomb had landed in the field at the top of Beach Road.

Another night, an incendiary bomb landed about 6 feet from the bedroom window. My grandfather shot out of the door with a bucket of sand. In no time, the incendiary bomb was extinguished. This small deed immediately elevated my grandfather to hero status. A few pints were downed at the Charlton after that.

During the Blitz period, the Dock took a tremendous pounding. Today, if you look carefully, you can see gaps in the original housing sites that have been filled with council and private development. This is particularly obvious in Market Street, Princes Street and Laws Street, and around Tri-Meyrick and Arthur Street. A memorial is needed before it is all forgotten. I remember looking at a house in Laws Street. The entire front had gone and a bed and wardrobe stood in the remaining half of the bedroom. I often wondered what had happened to the poor victims who were in that house.

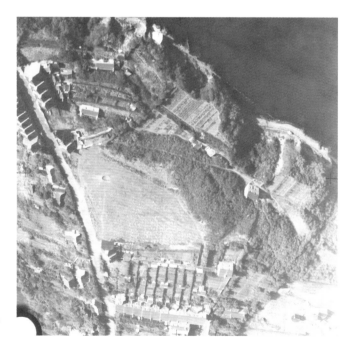

Oblique air photograph of
Llanreath, 13 August 1940.
(*Welsh Government*)

Things were hotting up. It was decided that my mother, sister and I should all move to Tenby. We first moved to Warren Street, where Jazz Radio and Ventrios Hostel are now. Also in the house was a Navy, Army & Air Force Institute (NAAFI) manager, Joffre Arthur. His place of work was in an old Sunday school hall, just down the road. It was not long before he left and ended up landing in North Africa on Operation Torch. He enjoyed a successful career, ending up as an NAAFI inspector in a warrant rank.

It was not long before we moved to Cresswell Street. During this period, my father was a serving professional soldier with the 1st Essex Regiment. At one time, he was stationed at Llanion Barracks. He and my mother met and married. When my father was posted to Egypt, my mother decided to leave me to be brought up by my grandparents, Edith and Sydney John. My sister, Charlotte, was born the day war broke out at Ismailia in the southern Suez Canal zone. Shortly after war was declared, my father was posted to Palestine. As a result, my mother and sister were sent home on the HMT *Dilwara*. Ken MacCallum and his mother were on the same ship, returning to Llanreath from Singapore.

Meanwhile, the 1st Essex Regiment moved north into Syria, heading towards Damascus. Several regiments of the Vichy-controlled French army occupied the area after the French had surrendered to the Nazis at Compiegne on 22 June 1940. Marshall Petain, the German-appointed puppet leader of the Vichy Republic, still had control of several overseas territories, one of these being Syria.

Meanwhile the Free French Forces, under de Gaulle, brought other military units over to the British side. Both sides contained units of the Foreign Legion. In June and July 1941, Allied forces (including Free French legionnaires and battalions of the 24ème) moved North

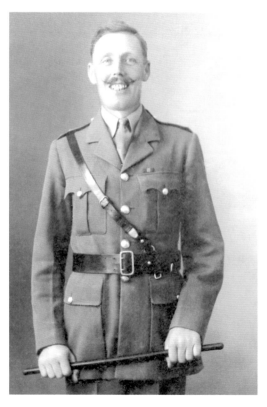

Len's father, Lt QM Ambrose. (*Courtesy of Len Ambrose*)

into Vichy-controlled Syria, meeting stiff resistance from the 6ème Regiment de Legion. They were defeated at Kiswe on the main Damascus to Amman road by the Gaullist 13ème Demi-Brigade of the French Foreign Legion.

My wife's uncle, Jack Evans, Welsh Guards, fought in the rear-guard actions at Dunkirk. He spent four years as a POW in a camp at Torun, Poland, 100 miles south of Gdansk. They took him out to be shot several times, and he was a broken man when he came home. He took part in one of the infamous 'long marches' when the Russians were coming through. If you could not keep up or go on, you were shot. No proper food was supplied. Prisoners had to moil in the field, like pigs looking for food. He never ate another turnip in his life. After eating rats, his heart and stomach were in very poor condition. He suffered death, by remote control, at a very early age.

During the war, the last person that you wanted to see was the telegram boy. It always seemed to be a small lad on a huge bike. My mother opened the telegram: 'The War Office regrets to inform you that No., Rank and Name has been killed in action.' My mother put her two hands up in the air looked at the ceiling and screamed, 'No!'

South of Damascus, the regiment had been running low on water. My Father and a driver set off in a bowser. A French fighter plane killed them both. They are in death as they were in life, together in a Damascus war cemetery. Eight gardeners tend the site of around 2 acres. The place is immaculate.

Up until a couple of years ago, no one had visited my father's grave. With the uncertainty of the political situation, it was out of the question. A couple of years ago, my wife Barbara and I took a holiday in Syria. What an emotional roller coaster that was. Barbara empathised with

In Memoriam

In Memory of
Lt. QM. W. L. AMBROSE
Pte. E. FOUNTAIN
1st Essex Regiment
My Father was killed with his driver, South of Damascus,
23.6.41. after being strafed by a Vichy French aircraft.
Because of the indecisiveness of the French Government at the
time the French fought each other in this campaign.
They also caused problems for my Wife's Uncle, Jack Evans,
Welsh Guards, who fought the rear guard action at Dunkirk.
He was captured with 452 others and finished up in a
P.O.W. camp in Poland for four years.
He was taken out to be shot several times.
As the Russians advanced an infamous long march ensued.
If you dropped out you were shot.
Lack of food forced them to moil like pigs for turnips.
I have been to Damascus War Cemetery twice where eight
gardeners look after about 1½ acres. The place is immaculate.
It's a deep source of worry to me about the fate of the gardeners,
as I see it they were working for me.
Years ago I visited a very large field with a village in the
distance. I imagined I was standing next to a stocky, dark
haired, Welsh man. He had a rucksack at his feet, with no white
flag in it. He took a deep breath and pulled back his long bow.
The peace Agincourt, death on the wing was setting off.
I had some satisfaction there.
L.A.

Lt QM Ambrose, *In Memoriam*.
(*Courtesy of Len Ambrose*)

me and shook for an hour. We intend to go to Syria again soon. If you are into Romans, the Crusades, the Bible and ancient history, this place is for you. I've got an expression about certain places in this world: you can open the hotel window and breathe in the history, even taste it.

Let us go back to the war in Pembroke Dock. For a short period of time, we lived at No. 17 Wellington Street. One night, the siren went and we could hear the planes overhead. Far above us, we heard a whistle. It came closer and closer and turned into a painful screech. We were underneath the table and nobody said a word. The whole house shook as the bomb exploded. We were OK, but the house at the top of the road had received a direct hit and people were killed. By now I was convinced that Hermann Goering was out to get me

I couldn't understand it, I didn't even know the man.

My wife's other uncle from the Royal Engineers, Ronald Evans, was seconded to Hell. He drove a bulldozer at Belsen, first digging a massive grave and then filling it with bodies of the Nazis' Final Solution. What thoughts must have gone through his head? Where was God? How could he have let this happen? Seeing and doing this job must have been a real test of faith.

My uncle, CPO Billy John, RN, was a regular Navy man. He had been torpedoed on several occasions. During an air raid in the port of Alexandria, he was out on deck when one of the ships received a direct hit. It must have been carrying ammunition as there was a massive explosion, the ship disintegrated and was gone. With it went Bill's mental state. After months of treatment, he made a full recovery.

In the early 1950s, my mother decided to remarry. It was to the man that she had met in Tenby all those years ago. Since 1947, he had been bulk supply officer for Shell at Sarawak, Borneo. She had to pass a mandatory examination for appointment in Milford. During

Len in 1949. (*Courtesy of Len Ambrose*)

a conversation with the doctor, it turned out that he was with my father when he died in Syria in 1941.

In 1939, my sister was born in Ismailia, Egypt. I spent five years in the oil industry 150 miles south in the Gulf of Suez. I joined the Army in 1949 as an apprentice radio mechanic. After a three-year apprenticeship, all signals trades had a meeting in the common room to select a posting choice. I chose Hong Kong, Cyprus, and Aden. The whole lot of us went to Germany to the HQ of the Northern Army Group Signals Regiment.

Since leaving the Army, my wife Barbara and I have been to Germany twice on holiday. I have come to admire them for their discipline, efficiency and willingness to work. On one trip we passed no more than 50 miles south of where Jack Evans was held as a POW in Poland. Knowing this, Barbara had brought his identity tags with her on holiday.

For me, something that put the whole madness of war into perspective was an experience that I had when serving in Germany. We were on manoeuvres and pulled into a farmyard to set up a transmitter station. When it was done, I intended to sleep in the barn. But the farmer insisted that I slept in the front room of the farmhouse. On the sideboard was a photograph to the farmer's son in uniform. Alongside it was a photograph of the headstone of his war grave.

Len and his sister Charlotte. (*Courtesy of Len Ambrose*)

Entertainment in Pembroke Dock During the Second World War

Frank Harris

As a military and naval base, Pembroke Dock received a tremendous amount of bombing throughout the war, with the loss of many people and servicemen. The Sunderlands at Pembroke Dock were at the centre of all the military establishments: Army units, the seaplane base, ship repair yards and fuel storage tanks. Often, the air raids took place in daylight, particularly when targeting the fuel storage tanks at Llanreath. I remember that day well. I was catching tadpoles near the railway tunnel and saw the German planes circle and dive to drop their bombs. The tanks burnt for days, with half of them being destroyed. Six firemen sadly lost their lives trying to control the flames and prevent further damage. As the air raids got more intense over the months, it was decided that residents at Llanion living close to the tanks should evacuate their homes in the evening. A Silcox bus would pick us up, taking us to Pisgah church hall near Carew and returning to collect us at 6 a.m. the next morning so that the men could go to work.

Although these were dark times in Pembroke Dock, I can also recall wartime memories of a more cheerful kind. My brother, Leslie, and I took part in the popular, morale-boosting variety shows. These variety shows were held at St Mary's Catholic church hall in Meyrick Street. In those early war days we had to make our own entertainment; it was common for concerts to be put on in the hall which became very popular, the hall being packed.

Father Daniels was the priest, and as a youngster I was an altar boy. We would be serving Benediction at 6.30 p.m. while people queued up outside to go into the hall. Looking at my watch, I would say to Leslie, 'It won't be long before we'll be singing on the stage next door.' By the time the service had finished, the congregation couldn't get a seat in the hall because it was already full. All the service personnel wanted to see the show.

A popular act was Dennis Williams, who played the ukulele and would sing in the choir at St John's, storing his ukulele under a seat in the vestry. As soon as the service was over, Dennis would hurry to the hall. Revd T. B. Lewis, from St John's, formed a concert party called the Blackbirds, which was likened to the Black and White Minstrel Show. The Catholic concerts that followed started to help morale.

As a consequence of being a garrison town, Pembroke Dock had Americans, Free French Legionnaires, Polish troops and Italian POWs (the camp was on the site where the 'blue school' is located). One can appreciate that concerts were extremely popular among the troops. Tommy Tucker would organise the Sunday night concerts, making everything run with a swing. Mr Levi Williams, the pianist, accompanied all the artists. Pam Crook (mother of Fiona Fullerton) was a regular act who used to sing and tap dance, as did Miami Waite, who sang beautifully. Dennis would say that the boys were 'all eyes' as Miami appeared,

dressed with a top hat, bow tie and fishnet stockings, singing, 'Put your arms around me, honey, hold me tight.'

Then there was Bert Wilcox who played the clappers, which lit up and sparkled as he played. For this, the hall lights were turned out. Trevor Owen and Gwyn John were brilliant whistlers; one of their favourite tunes was 'In a Monastery Garden'. The bird sound that they could produce by merely pursing their lips was incredible. Trevor Morgan was a very good tenor and sang many lovely ballads of a romantic and sentimental flavour.

Leslie (aged ten) and I (aged eleven) would perform a double act based on the Flanagan and Allen sketches, which were hugely popular at the time. Flanagan always wore a fur coat and floppy hat; our mother improvised, making the costumes from flannelette sheets with black strips down the sides of trousers and black lapels – truly unbelievable. We managed to get hold of two top hats. Performing Flanagan and Allen's well known songs, such as 'Underneath the Arches', we would encourage the audience to join in.

Dennis Williams would play a selection of George Formby's songs and other popular choices. When the 110th American Division was stationed at Llanion Barracks, he used to play American numbers like 'Deep in the Heart of Texas' and 'Ragtime Cowboy Joe'. I have many fond memories of these marvellous shows. We performed in other local venues aside from the church hall, in Angle, Cosheston, at the Llanion Barracks and the garrison chapel. We enjoyed every single moment. When performing in the villages, the food laid on was exceptional, rationing seeming not to apply.

I can recall one incident that occurred while playing in either Angle or Cosheston. It concerned another regular act, Selwyn Gwyther, who used to play the saw. It was placed tightly between his legs and played with a violin bow to create a vibrating effect. His

Leslie and Frank Harries. (*Courtesy of Frank Harries*)

favourite piece was 'Just a Song at Twilight'. This particular night, as we watched from the wings, Selwyn's face went taut – cramp must have set in. He played on regardless, when suddenly the saw sprung up and hit him under the chin, causing his toupee to fly into the audience. You can imagine the laughter. That night was talked about for weeks.

On many occasions, I would assist the American chaplain to the 110th American Division, Catholic priest Father Werpechowski, to serve Mass. We would usually go to the Llanion Barracks, or other camps where troops were stationed. Just before D-Day, there was considerable tension, so Father Daniels arranged a small concert. Impromptu concerts took place so that people, and especially the troops, could have a little relaxation. Gen. Eisenhower visited the troops, giving them a pep talk in readiness for the invasion. Both Dennis and I received bibles from Father Werpechowski; mine was a Roman Catholic one signed by Franklin D. Roosevelt, dated 6 March 1941.

From my schooldays, I was envious of Arthur, a friend of mine who was a messenger boy. I wanted to become one so that I could wear a tin helmet. On the way home from school one day, Arthur and I called into the ARP office located behind the Bush Hotel. I was given the form, and told to ask my father to sign it. Then, Arthur and I made our way home along Bird Cage Walk and over the style at Llanion. The last words Arthur said to me were, 'Ask your father to sign the form, and then hand it to me in the morning or at school.'

That night, there was heavy air raid, and on arriving at school the next morning I was asked to go and see the headmaster. He told me that two messenger boys, Arthur Kavanagh and Cyril Jenkins, had been killed during the air raid. I had lost a good friend in Arthur. I never became a messenger boy.

THE WHITE HOUSE
WASHINGTON

March 6, 1941

To the Members of the Army:

As Commander-in-Chief I take pleasure in commending the reading of the Bible to all who serve in the armed forces of the United States. Throughout the centuries men of many faiths and diverse origins have found in the Sacred Book words of wisdom, counsel and inspiration. It is a fountain of strength and now, as always, an aid in attaining the highest aspirations of the human soul.

Very sincerely yours,

Franklin D. Roosevelt

Frontispiece of the issued Bible, US Army.
(*Courtesy of Frank Harries*)

The Bombing of the
Llanreath Tank Farm

Ken MacCallum

It was a summer morning, around 11 a.m., when there was a loud explosion followed by the air raid siren and a series of smaller explosions. Unlike at the Coronation School, no precautions had apparently been made for the protection of staff and children at the Albion Square School. So we were all sent home (in my case only to be promptly sent back to school). Soon it was all over, with no casualties on either side. There had been token resistance from a Lewis gun at the Defensible Barracks, but nothing else. A large bomb had

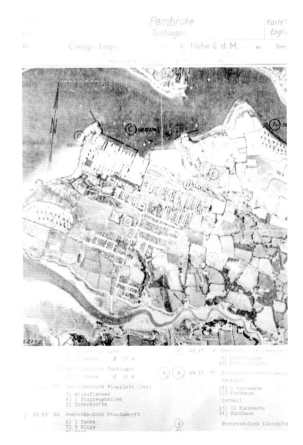

Luftwaffe reconnaissance air
photograph of Pembroke Dock, 1940.

been dropped off Hobbs Point, and a stick of smaller bombs off Llanreath beach (with the last of that stick falling in a field about 100 yards from our house).

That evening, I joined a group of Llanreath kids on the beach hunting for shrapnel. I failed to find any, but one of the 'big boys', Bill Barnikel, gave me a piece. It was about palm sized, made of aluminium and painted red and green. It could have been a piece of the tail fin of a bomb. My grandfather cut a small piece off for a friend of his, giving me sixpence in return, which I spent. Recently, someone 'nicked' my treasured piece of shrapnel. The bomb that had fallen in the field had cracked and peppered with shrapnel the pine end of 'Cheriton', a house at the top of Beach Road, but that was the only damage caused.

In school, there was a rapid change of attitude. We were no longer to be sent home during an air raid. Instead, we were given our own private air raid shelters. Also, the large windows were taped to reduce the effect of the blast splintering and blowing broken glass everywhere. This was later reinforced with fairly coarse netting stuck on the windows. Our private air raid shelters were made from available materials. We all had single desks with a cast iron frame, opening desk top and tip-up seats. There was also a plywood board, about 36 inches by 18 inches and a raffia mat around the same size. During an air raid, we were drilled to tip up the seats, put the board from the desk top to the seat back and drape the raffia mat over the top to give us some protection from flying glass. We would sit inside our mini shelters, while our teacher, Miss Davies, a tall, elegant lady, walked up and down to ensure that we stayed inside our shelters. At the time, trenches were being dug in the playground as air raid shelters and, eventually, the familiar brick-built shelters were constructed.

At this time, my father was stationed in Belfast. My grandfather was locally employed in the ordnance depot. My grandmother, who had had a stroke, was virtually bedridden and my brother was not yet one year old. So, the decision was taken to move somewhere quiet. For the next eighteen months I lived in Manorbier Newton and went to Lamphey School. A bit of a culture shock for me, but a lot of fun as well.

The raid was successfully carried out by three Junkers 88 bombers on Monday 19 August 1940. Dropped from a low level, the bombs hit the eastern end of the tank farm, resulting in the destruction of eight of the oil tanks and a loss of an estimated 33 million gallons of

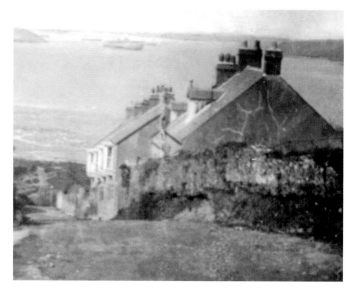

The pine end of 'Cheriton', showing, patched up blast damage still evident in 1945.

fuel oil. It was a successful raid, as the fire burned for three weeks. Initially, it was fought by the local fire brigade, under the leadership of the Pembroke Dock fire chief, Mr Arthur Morris. It was soon realised that the fire was beyond control and eventually there were over 600 men from twenty-two brigades fighting the fire. When it was all over, the awards were given, although none went to the leader of the Pembroke Dock fire brigade, fire chief Morris, who initiated the response and the successful planning of the fire-fighting operation.

The raid was a success for the Luftwaffe. But then there was no RAF. A lone Avro Anson did get a photograph of the fire shortly after the raid. In addition, there was a Fleet Air Arm Walrus that bumped into the Ju 88 formation. The top speed of the Walrus was about the same as the landing speed of the Ju 88. So no contest there, then. The raid possibly hastened the provision of local anti-aircraft defences. There was even a Bofors gun in Llanreath a year or so later. It was not long after D-Day that it vanished.

The full story of the raid has been told by Vernon Scott in his book *In Harm's Way*. and also by Bill Richards in Pembrokeshire Under Fire. They provide an excellent and full account of the incident.

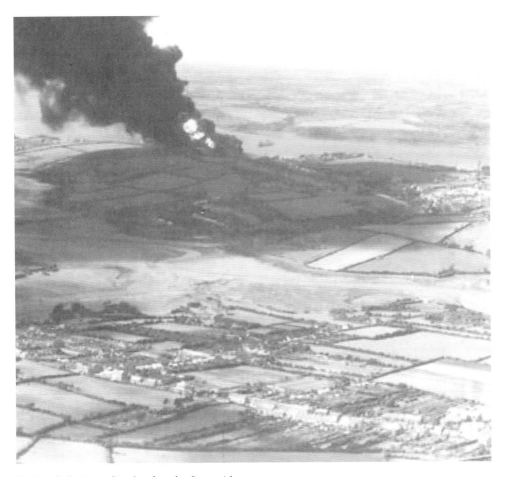

Tanks alight immediately after the first raid.

Extracts from the Pembroke Grammar School Website

Edited by Morgan Allen
Introduction by Phil Carradice

Introduction

Contrary to popular belief, Pembroke Dock was never a naval town. Ships were launched from the dockyard and sailed away, most of them never to grace the waters of the haven again. The place was, above all, a dockyard town. The distinction may be subtler but it is crucial; it was certainly a military town, after all, dockyards needed to be protected. From 1930 onwards, it was also an air force town. Any of those would have been enough to make Pembroke Dock a viable target for German bombers during the early years of the Second World War. All three meant that, sooner or later, air attack was inevitable.

The raids on Pembroke Dock were of such ferocity that, for a while at least, when you consider the size and population of the town, the death toll and damage were as proportionally high as almost any community in Britain. Children of the baby boomer generation, if they did not experience the bombing first hand, certainly had relatives who were more than willing to talk about it. I remember, as a child in the 1950s, walking down streets that had more than their fair share of bombed-out buildings. The evidence of the Pembroke Dock blitz was still there, for all to see.

People's memories and the stories passed on from one family to another make fascinating reading (or listening). Oral history may not always be strictly accurate (Lord Haw-Haw did not promise to spare pretty little Tenby, as my mother never tired of telling me) but it is endlessly fascinating and highly enjoyable. It is history as people remember it, and after all history does belong to the victors, or in this case, to those who are telling the tales. For this reason alone, these stories should be read, appreciated and passed on to the next generation or two.

Where Were You When the Bomb Dropped?
Jack Blencowe (Pembroke Dock County School 1935–42)

There are events that stick in the mind. Where were you when you heard the news of President Kennedy's assassination, or the death of Princess Diana? For me, the day the oil tanks at Llanreath were bombed is one such unforgettable occasion. Despite its dockyard closing in 1926, Pembroke Dock was still an important military base and Army barracks, comprising a major RAF coastal command base, a small shipyard repair dock and two large naval oil storage depots.

The first air raid I remember, in July 1940, was by a hit-and-run bomber that targeted the oil tanks at Pembroke Ferry. Rumour had it that one tank had been hit but the bomb failed to explode. Built before air warfare was seriously considered, the tanks there and at Llanreath were perched on hilltops. Following the fall of France, they were within

easy reach of German airfields and the tanks could be seen 20 miles away. There were several minor raids in the weeks that followed. I remember cowering in the cellar as bombs came whistling down. It was a lovely summer and a group of us borrowed a bell tent and camped at Freshwater East. Among us were Gwilym Pendleton, Peter John, Eber Cox and his younger brother and maybe one or two others. On 19 August, having heard a loud explosion and seen the black smoke of an oil fire, we got on our bicycles and headed for Pembroke Dock to see what had happened. From the Barrack Hill we could see that tanks had burst and the moat around them was filled with blazing oil. Firemen were spraying water onto the blaze but the burning tanks themselves were beyond the range of the jets.

Unusually, the wind blew steadily from the north-west, sending the dense cloud of smoke across the Bristol Channel towards Devon (where it was said to have tainted the apple crop). We returned to our tent at Freshwater East and continued to enjoy our holiday. The morning sun had disappeared behind the smoke by mid-morning, but we still had a lot of fun.

There were several periods of excitement when German planes flew in the shelter of the smoke cloud and bombed or strafed the fire fighters. The fire finally burnt out after twenty days, by which time I was back home. The wind had finally backed to the southwest and I remember that last night seeing flames in the smoke cloud directly over Church Street. Had the wind changed direction, I doubt whether the town would have been habitable. A resident of Llanstadwell told me that a thermometer on his front porch rose and fell ten degrees as the flames surged up and down. Back in town the air raids were frightening. The temperance hall at the bottom of Lewis Street was hit and I believe fire fighters were inside sleeping on camp beds, although I don't know if there were any casualties.

Pembroke Dock and the Blitz
William Smith

On Monday 19 August 1940, I was taken by my uncle, a commercial traveller, to Tenby. As we returned home at about 3.30 p.m., we saw a vast plume of black smoke rising high into the sky over Pembroke Dock – it was the day when the oil tanks were hit. For nearly three weeks, the sky was blackened by day; any washing hung outside gathered an oily film and the town had a pervasive stench of oil. By night, there was a fiery inferno, which attracted many people to the top of Barracks Hill to watch the spectacle on the first night. Luckily, we all left the scene before the enemy returned to machine gun the area where firemen were battling overwhelming odds. From the door of my parents' house in Laws Street, I watched excitedly as fire brigades (from Haverfordwest, Carmarthen, Swansea and then Bristol, Cardiff and Birmingham among others) rushed through the town to the assistance of their colleagues. A great thrill for a young boy. For those three weeks, we had exhausted firemen coming to our house to sleep by day and night – never an empty bed. One day, we all went to Park Street to mourn the loss of five firemen from Cardiff who died in the inferno, watching the procession as their funeral left the mortuary

Pembroke Dock at War
Audrey Watson

On 19 August 1940, my sister and I happened to be looking out of our bedroom window in Tremerick Street when a German plane bombed the oil tanks at the top of Military Road, Pennar. A dreadful explosion followed and then an inferno which lasted for eighteen days. We saw it all happen. The local fire brigade, led by chief fire officer Mr. Arthur Morris, with back up from other counties, was heroic in fighting the blaze. Sadly, there were casualties. Due to the dreadful smell of the oil in the air, we were advised to fill basins, buckets and pans with water and put them

around the house. The droplets of burning oil from the tanks settled on the water, which had to be regularly changed. This went on as long as the tanks burnt. Here, I must say, the firemen were heroes, but I was saddened and disgusted to learn much later that all the members of the fire brigade had been recognised and were given medals, with the exception of Mr Morris.

Where Were You When the Bomb Dropped?
Margaret J. Trobridge *née* Knight

I was almost twelve years old when the war started, so only one year of my time at Pembroke Dock County School was during peacetime. Thereafter, it was five years disrupted by disturbed nights. Apart from the air raids, we were often awoken by the siren when planes were passing overhead, presumably on their way to other targets. My class spent some time in the nearby St Andrew's church hall, a gloomy, depressing place. There were several changes of staff as the younger ones left to join the forces.

We lived at the Prospect Tavern in Prospect Place. At the start, my mother fitted out part of our cellar with bunks and a few essentials, but before it was even used my sister asked where the shovel was in case we needed to dig ourselves out. That shelter was abandoned, as was the Anderson shelter in the garden, which my mother said was too damp and spider infested. In the end, she decided that our safest option was to crouch on the cellar steps.

Most of us must have been remarkably naïve about the danger of the bombing, for on the evening of the day on which the Llanreath oil tanks were set on fire, I along with many others paraded along the top of Barrack Hill marvelling at the spectacle. We soon changed our attitude when the fire raged on and lives were lost. Firemen came from other parts of the country and between shifts sought a few hours rest wherever they could. I remember two blackened and exhausted men from the Midlands snatching a few hours of sleep at our house. I am not sure but I think it was at this time the temperance hall was destroyed and some firemen billeted there were killed or injured.

One of the attempts to destroy the Llanion oil tanks was a sudden mid-morning raid. It must have been holiday time, for we were not at school. It was a brief attack and as soon as it was over we came out with most of our neighbours. With a clear view, we could see that the Llanion tanks were undamaged. Unfortunately, the 'all clear' had sounded too soon and one of the enemy planes suddenly reappeared flying low and machine gunning indiscriminately. We all ran like rabbits back to our holes!

On the Day that the Luftwaffe Bombed the Oil Tanks
Dennis Williams

On the day that the Luftwaffe bombed the oil tanks at Llanreath, I was 20 miles away in the north Pembrokeshire village of Clunderwen. I was a ten-year-old schoolboy helping to deliver wholesale bakery supplies to bakehouses throughout Pembrokeshire. Mr Teddy Davies, of Water Street Pembroke Dock, was the agent for DCL Yeast in Swansea. His job was to deliver yeast, butter, margarine, cooking fats and jam for baking. At this time, all these commodities were under strict rationing control.

Around two o'clock on this day, we were unloading the van when we saw a thick black plume of smoke spiralling into the sky from the direction of Pembroke Dock. Mr Davies, our local air raid warden, immediately concluded that the town had been attacked and set on fire by the Luftwaffe. Not knowing the circumstances, we made haste back to the Dock to find out what had happened.

Mr Davies dropped me off at my house, making sure that I was safely home. I checked with Mam and she told me that there had been an air raid and that a German bomber had

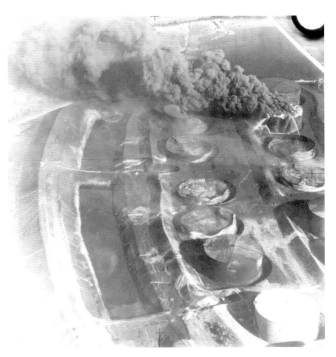

Above left: RAF oblique air photograph of tanks destroyed and burning. (*Welsh Government*)

Above right: George Lewis, a PDCGS pupil. (*Courtesy of George Lewis*)

bombed the oil tanks at Llanreath. The all-clear had been given, so it was safe go outside and carry on as normal. I decided to cycle up to Pennar to see what had happened. When I arrived at St Patrick's church, I could see that there was pandemonium. The police had sealed off the eastern end of Military Road, only allowing emergency vehicles through. They included fire engines and tenders, ambulances and military vehicles. A huge black cloud, which passed along Military Road and Pennar, rained sticky black oil onto the houses. It covered the roofs and ran down over the walls and windows and into the gutters. It was a terrible sight to see. Luckily, no civilians or military personnel had been killed.

In 1940, the only anti-aircraft defences were sites prepared for Lewis guns (First World War vintage machine guns). They were not permanently manned. It was said that the Army targeted some rifle fire at the planes and some ships in the harbour had a pop at them as they flew down harbour. But to no avail.

Sadly, there was loss of life fighting the blaze, which lasted for three weeks. Five firemen from one of the Cardiff brigades were caught in a 'boil over' from one of the burning tanks. At the height of the fire, there were over 600 firemen involved. Temporary accommodation was arranged for them at St Patrick's church and the temperance hall in Lewis Street. One of the reasons that the fire burned for so long was the large tidal range. A network of hoses was led out over the old iron pier at West Pennar, and they maintained suction for the major part of the tide. However, the hoses led down the valley and out on to the beach at Llanreath, losing suction at half tide. It was a major logistical operation to keep sufficient water pressure at the pumps.

The First 'Four-Minute' Mile
Ken Thomas

It was after lunch on a lovely warm summer's day, on 19 August 1940. The British Commonwealth was at war with Nazi Germany. But in Pembroke Dock, there had only been a few air raids at a fairly low level. This was about to change. This account concerns my personal experience of the bombing of the tank farm situated at the western end of Military Road, close to the Royal Engineers' Barracks and workshops. I was eleven years old and, on this day, I was at No. 102 Military Road. This large house with a big garden belonged to an aunt of mine. She lived on her own, so my father prepared and planted the garden. The crops that were produced were shared between my family and my aunt.

I was in the garden digging potatoes when I heard a loud noise and the roaring of aircraft engines. I first thought that it was a Sunderland coming in to land, but it did not really sound like one of them. I went round to the front of the house to have a look. It was a large aircraft with two engines, but it was missing the RAF roundels on the wings or the fuselage, and it looked all wrong. Then I noticed that it had large black crosses instead. There were three of these aircraft and they had come from the direction of Monkton. By the time I realised that they were Nazi planes, I saw three large black things leave the belly of the aircraft. I thought that they looked like bombs. That was it. I took off for home, No. 6 Military Road.

I don't know how true it is but I have always believed that Military Road was a mile from beginning to end. I am absolutely positive that I covered that distance in less than 4 minutes. I hesitate to write to Sir Roger Bannister as I would hate him to be so disappointed after all this time, but I know that I am the first 'four-minute miler'! If I had teamed up with Len Ambrose, we would have swept the board at the 1948 Olympics.

My father was in the Army Fire Service, and was totally involved in fighting the fires at the tank farm. As a young boy, there was not a lot that we could do. But my brother and I used to go to St Patrick's schoolroom, where firemen were staying, and help with washing up. On one occasion, my brother and I were given some fruit that was about 6 inches long and yellow. We were about to eat it, when my mother said that you have to peel it first. This was the first time we had ever seen a banana!

Memories of a 1940s Pembroke Dock Schoolboy
A. H. Macdiarmid Air Raid Precautions

At the Coronation School, the outside walls of the ground-floor cloakrooms had been heavily sandbagged to act as air raid shelters. From the start of the Second World War, classes had regularly practiced filing down and taking up their positions, sitting against the walls.

One day there was an actual air raid warning. We could hear the aircraft engines so we sat around our shelter with a certain apprehension. One boy from King Street, whose name I can't recall, blew up a paper bag and then let it off with a bang. This caused a minor panic among some of the younger boys. For this act, he was given a dose of corporal punishment when the all-clear sounded. After this, we found out that the alarm was caused by our Sunderlands flying about, so nothing happened.

The First Bomb on Pembroke Dock

It was the middle of the afternoon, playtime at the Coronation School, and Mr Blencowe was on playground duty. A dark-coloured aircraft was circling high above the town. All the experts were discussing whether it was a Junkers 88 or a Heinkel 111. Mr Blencowe said, 'It can't be a German aircraft, as no one is doing anything about it and no siren has

sounded.' We returned to our classrooms and continued with our lessons. Ten minutes later, there was an enormous bang, followed by the siren. We then followed our well-practised air raid precautions. Somehow, word got round the school that the bomb had landed in a field in Pennar. At the end of the school day, just about every boy in the Coronation rushed up to Pennar to see the crater. It was right where the golf club is now.

Every boy there was digging and scratching about looking for shrapnel. After a while, a very senior Army officer, accompanied by a junior one, came to inspect the crater. 'My God,' said the former, 'that is a big crater for a 25lb bomb!' To which the junior officer replied, 'It was not that big to start with, Sir. It's due to these children searching for souvenirs!'

The Llanreath Tanks Fire

During the summer holidays, my brother and I, along with another boy, Frank Humphries from Sycamore Street, were constructing a boat from an old packing case. We had been given permission to use the old isolation hospital at Jacob's Pill, Bufferland, which had been empty for years, but there was a watchman living in one of the empty rooms. During the Battle of Britain, he used to run in and give us the number of aircraft that had been shot down, almost like a running commentary on a cricket match.

One morning before lunch, we were outside on the grass, along with just about every other other child in Bufferland – it was the place to play. There seemed to be aircraft flying all over the place, although this was not unusual in those days, so no one took much notice. Then I saw three aircraft flying very low towards the tanks at Llanreath. I said to my

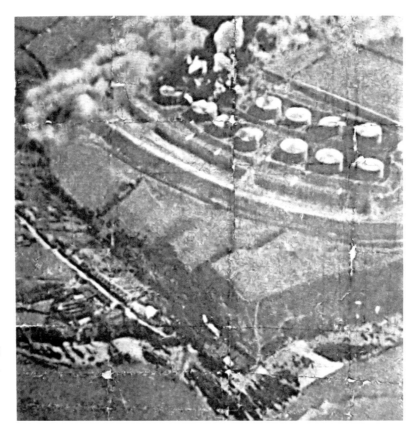

Luftwaffe photograph of tanks burning. (*Courtesy of the* Penvro Journal)

brother, 'Look at those seagulls flying so close together.' They weren't seagulls at all – they were the bombs falling that hit the tanks and set them on fire. An eleven-year-old girl, who was on Military road, claimed that one of the pilots waved to her as he made his bomb run: 'The aircraft were so low that I could have thrown a stone and hit them with it!' While this is unlikely, it is true that they were flying very low.

The following Sunday morning, after returning from church, I was out in the garden at the rear of No. 26 North Street, which overlooked Bufferland Pill. I was looking at the large column of smoke from the oil tanks that blew over the Pill towards Pembroke. Emerging from the edge of the smoke, I saw a silver aircraft with a large black cross on the side of the fuselage. It was a Heinkel 111 with a very distinctive glass nose, which made for easy recognition.

The fact that it was polished rather than painted, and did not drop any bombs, probably meant that it was a reconnaissance version of the Heinkel 111 bomber and it was photographing the result of the previous air raid. No one else seemed to have seen this aircraft, but I know what I saw. This is borne out by the copy of the photograph [shown opposite] that was published in the German press around this time.

Air Raids on Carew Airfield

As the enemy was paying attention to Pembroke Dock, my mother decided that it would be safer for my brother and I to spend the summer holidays with our grandparents in Carew Lane. Carew Airfield was raided twice during our stay. From the lane, we could look down upon the airfield, and on some mornings a range of aircraft types could be seen parked up in dispersal, either because they were running short of fuel, or were damaged by enemy action. I once saw an American B-17 Flying Fortress there.

Late one summer evening, my grandfather and us two boys were standing on the lawn beside the house and listening to an aircraft circling around. It was dark, and Granddad said, 'It's one of ours, trying to find the airfield in order to land.' 'No it's not,' we said, 'it's a Jerry.' In those days, all schoolboys were experts at aircraft recognition, not only by sight, but by their sound as well. After a few more circuits, on went the plane's landing lights. 'There,' said granddad, 'It's one of ours.' The ground staff at Carew Airfield thought so too, as on came all the runway lights. At this, the aircraft extinguished its landing lights, roared over the camp and bombed the place. Jerry had a few tricks up his sleeve as well.

The other air raid was early morning, just as it was getting light. We were awakened by the sound of explosions and machine gun fire. The airfield had copped it again. That morning, we had an early breakfast. The news quickly got round that incendiary bombs had landed in the cornfield opposite our house. We boys finished our breakfast at the speed of light and were soon out in the field with shovels, helping to put out the still burning bombs.

In the early morning light, the field below the plane must have looked to the German airmen like a field of standing corn. But it was only stubble, as the corn had been harvested the previous week, so no real damage was done. We all kept the fins of the incendiary bombs as souvenirs. I recently gave mine to the Carew Airfield Museum.

Postscript

The photograph below of a young lady leaning attractively on a boat was taken in 1944 on West Pennar Beach in Pennar Gut. The boat would appear to be painted a dark colour below the waterline. It is not paint, but burned fuel from the tank fire. Before being repainted, this would have to be scraped off, then washed down with paraffin and sanded. It would not

A girl and a boat.

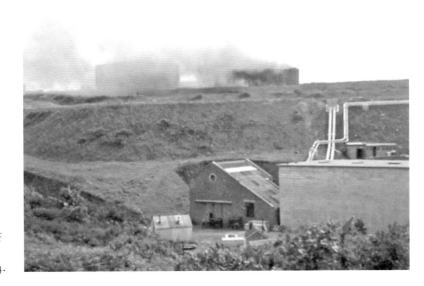

The second tank fire and demolition of the damaged tanks in 1954.

happen today; it is against the rules of the Milford Haven Port Authority to keep small boats on the beaches in the Haven.

The year 1954 saw the tank farm dismantled and scrapped. Part of this work involved taking down the two fire-damaged tanks at the east end of the site. There were sufficient volatiles in the tanks for them to catch fire. The photograph shows that it was small beer compared to the summer of 1940.

Growing Up in Llanreath

Joe Barnikel

Growing up in Llanreath during the 1940s and 1950s was very different to growing up today. Radio was the only form of contact with the outside world and play mostly involved making dens in war-damaged or abandoned properties. Those properties not quite damaged enough were soon modified. Batons from slated roofs were ideal for making stilts and the art of walking with stilts was soon acquired. We all had some sort of knife or catapult and we could all make and light a fire and mend a puncture in a tyre or ball. Most of us could swim, having learnt from the older boys on Llanreath beach.

Our first chemistry experiment was carried out by 'Professor' Leonard Ambrose at the back of the ammunition dump just outside the dockyard gate. My brother Max and I, along with Len, picked up an emergency flare at the high-tide mark. The idea was to empty the flare and then set fire to the contents. It was a complete success; a large ball of flame erupted and we all got burnt.

Len and Ken, two of the 'older boys'.

Fortunately, Ken MacCallum's dad had just walked past on his way home from his job as inspector with the dockyard police. He took us back to his office and called the RAF medical team based in the Sunderland flying boat base just along Fort Road. They had plenty of experience in dealing with burns. A long ride via Canaston Bridge took us to the county hospital in Haverfordwest, where we stayed for two weeks until recovered. Len never did make it in chemistry.

In the 1940s, Llanreath must have had the best selection of rope swings in West Wales. A generous supply of rope was available from the MoD via the wireless field pylons, which must have been 100 feet high. Most swings were located over the bank between Atkins' Orchard and Tom Germain's. The stream on the south side of the bank could be dammed off to provide great water hazards and there were many wet backsides to prove it.

The end of the war in 1945 brought the end of blackouts, and we were able to build a bonfire to celebrate VE day. What a bonfire we built! All the boys set to work cutting gorse bushes on the Barrack Hill using hand axes. There was an art to building a bonfire. A tunnel was constructed at the base and this was filled with old newspapers collected from all the houses. Our favourite house was the Claypoles', in Victoria Road. They owned the Grand Cinema and had a selection of magazines containing pictures of all the Hollywood stars. These were fantastic but did slow up the collection process.

Sod fights were another important part of bonfire building, with a ready supply of square-cut turf available from the Barrack Hill. A good supply of ammo was essential in case we were raided by the Pennar boys, who were intent on setting fire to our bonfire. Our VE Day bonfire was a great success, so much so that we had to do it all over again for VJ Day and then again on 5 November for Guy Fawkes. 1945 was a great year for bonfires and for pruning back the gorse on the Barrack Hill.

Camping was pretty much a way of life for the nine-week school summer holiday. Our campsite was above the beach and our tents were a very mixed bag of very basic canvasses, mostly waterproof. Later, we were given a walk-in marquee tent, which was great. Cooking

The swing. (*Courtesy of Joe Barnikel*)

The Llanreath gorse cutting and protection team. (*Courtesy of Joe Barnikel*)

The 'happy campers'. (*Courtesy of Joe Barnikel*)

was limited, done over a wood fire, but we all survived.

I hear some of today's generation of children are suffering from rickets due to a lack of exposure to the sun. There was no danger of that with us. We usually acquired a very healthy tan from our outdoor activities of swimming, mud-larking and apple-scrumping. A week spent in Llangranog Urdd campsite made a great difference to our singing. Cyril MacCallum and I spent a week at the all-Welsh language camp courtesy of Pembroke Dock Grammar School. It was great, singing all day and learning all the songs. On our return, we passed on all we had learnt to the other boys and we were in fine form by the end of the summer. The women in the village even complimented us on the quality of our singing, although our late-night efforts weren't so well appreciated.

Most of the boys had bicycles, and as we got older our range of cycle trips broadened. Trips to Freshwater East, Lydstep (for daffodils) and Whitesands Bay were popular, and St Davids, the Preseli Hills and Castlemartin (no military restrictions) were also on the agenda. One of the regulars at Freshwater East each summer was a lad who cycled down from Birmingham. I think he must have inspired me, for a few years later Terry Armstrong and myself cycled to London via Penarth, Weston-super-Mare, Bath and Englefield Green. We made Bath in one day – 140 miles was our all-time best effort. We continued from London to Dover, Hastings, Brighton, Portsmouth, and then over Salisbury Plain to Weston. There we caught the ferry to Penarth and back to Llanreath.

We impressed ourselves enough to plan a cycle trip to Paris for the following year. Unfortunately, Terry had to drop out but another good friend, Dudley Davies, stepped in. He was from Cosheston, an apprentice at Davies Steel and a Quins rugby player. We retraced our route to Dover, crossed on the ferry to Calais, then on to Paris and Dieppe and back via the ferry from Boulogne. It was very hot and the French roads were long and straight, but we had a great trip. No mobile phones or satellite navigation to help us in those days, but we made it all the same. Halcyon days.

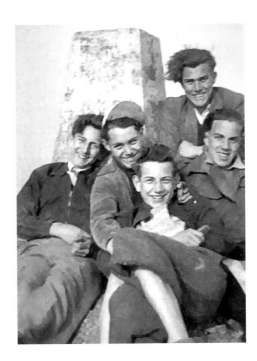

The original 'bikers' at the summit of Cwm Cerwyn, 1949. From left to right: Ken MacCallum, Neville Smith, Peter Stanley, Joe Griffiths and Derek Williams.

Memories of an Apprenticeship with R. S. Hayes, Pembroke Dock

Joe Barnikel

The 1950s were a good time to start learning a trade in the old Royal Naval Dockyard at Pembroke Dock. The major part of the dockyard had recently been acquired by R. S. Hayes as a ship repair and building yard in response to the post-war changes within the shipping industry. The change from ship repair to shipbuilding required a whole new set of skills.

Four large launches were required for West Africa. They had been built and delivered. This was followed by the Norrad Star, launched in July 1956 for the Milford Haven trawler fleet. She fished out of Milford for the next thirty years before being beached off Front Street, Pembroke Dock, prior to being broken up.

This change in direction required a newly skilled workforce of craftsmen, and in due course a wide range of apprenticeships was offered. By the mid-1950s, the system was well

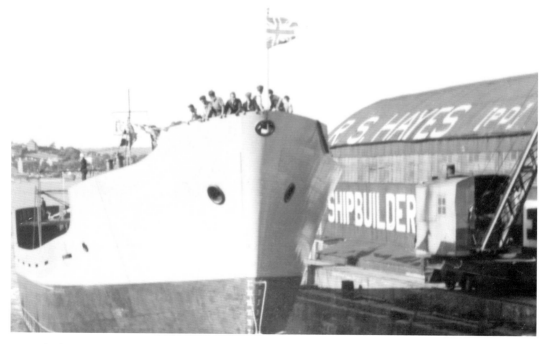

The launching of the *Norrad Star*. (*Courtesy of Phil Carradice*)

established, with the appropriate ratio of tradesmen to apprentices. Evening classes were held in the old Coronation School in Meyrick Street, then came day release, initially to college in Carmarthen and then to the new college in Neyland. This gave many apprentices the opportunity to enhance their academic qualifications.

The five-year duration of the apprenticeships covering the age range from fifteen to twenty-one years meant that many young men stayed in the local community. This was of huge benefit to the local sports clubs (and girls!) in the catchment area.

Rugby was the premier sport of Pembrokeshire and Wales and we'd all learnt to play in the schools. Pembroke Dock Quins Rugby Club ran three teams, helped by the ready supply of apprentices from the shipyard. The club was 'run' from the Edinburgh Hotel in Dimond Street. This was just as well because facilities at the Bierspool ground were somewhat basic. It was in the Quins' bar that we all learnt the club rules, such as how to consume large quantities of ale and learn to sing all the club songs. Instructors included Gwlim Pendleton, Walford Davies and Steve Johnson, with Timmy Hay, of course, as master of ceremonies.

Building new vessels was a welcome change from keeping old ships repaired and running. It also meant that a new set of skills had to be employed. This in turn did cause some friction in the work force, particularly with the increased use of welding rather than the traditional riveting. The *Norrad Star* was the first fair-sized ship to be built. We had to start from scratch. For example, the stern frame required boring out in order to fit a stern tube to carry the propeller shaft. This needed to be accurate otherwise the ship would move in a circle. A boring bar had to be machined – a solid 3-inch by 10-foot steel bar with a groove cut the length of it to hold a threaded rod that would move the tool holder. A piano wire running through the centre of the engine room to the rudder post gave us the correct alignment. This work was carried out while the boilermakers were riveting all around

PDGS first fifteen, 1953. (*Courtesy of Joe Barnikel, back row, centre right*)

us. Health and safety at work had not arrived in the 1950s, so ear protection, hard hats, goggles, gloves and safety boots were all absent!

Communal toilets were the order of the day ... Six seaters with partitions and one flush upstream served all. While this process was in action, a lighted newspaper upstream usually cleared the berths further down. Burning paper wasn't the only hazard. One day, one of the boys leapt up with a frightened rat attached to his lower appendages!

The pace of life was somewhat slower in the 1950s. With only steam-driven cranes on fixed rails available for lifting, our work pace was also slower. Commuting to the dockyard, a walk round the beach from Llanreath, was fairly easy when the tide was out. The alternative and longer route was down through the wireless field. I could see from this vantage point the number of workmen on Fort Road heading for the dockyard – more than 500 at the peak.

Naval contracts were an important part of the early work. In 1957, a Bay class frigate, HMS *Porlock Bay*, was refitted for RN service. HMS *Eggesford*, a Royal Naval Hunt class destroyer, had been converted and handed over to the West German Navy as the training frigate, Brommy. Our job was to fit the craft out to their specifications. It did seem rather strange to be working alongside German officers. Many of the yard's tradesmen had been involved in fighting against the Germans only ten years earlier.

The Empire Frome was a German vessel still under construction at the end of the Second World War. She was a general cargo vessel of some 4,800 gross tons under construction at Flensburg in May 1945. By 1948, she was completed and transferred to the British Ministry of War Transport to sail under the British flag. She was sold in 1953 to Submarine Cables Ltd and arrived at R. S. Hayes, where she was to be transformed from a general cargo ship to a cable layer. She was completed in July 1955 and renamed the Ocean Layer. This change of name was viewed with superstitious foreboding by most British merchant seamen. The work on this contract was a complete contrast to the majority of the yard tasks and it was hard to believe that this vessel would lay cables thousands of miles across the ocean seabed. A mere forty years later, the same communication links would be carried by satellites 22,000 miles above the earth. In the 1950s, that notion would have only been thought possible in Dan Dare of the *Eagle*!

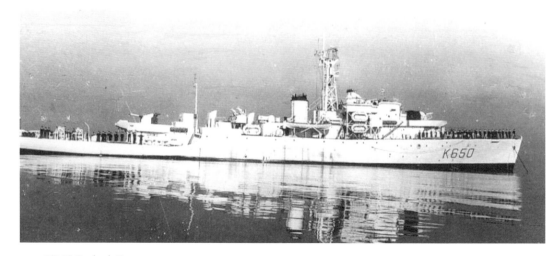

HMS *Porlock Bay*.

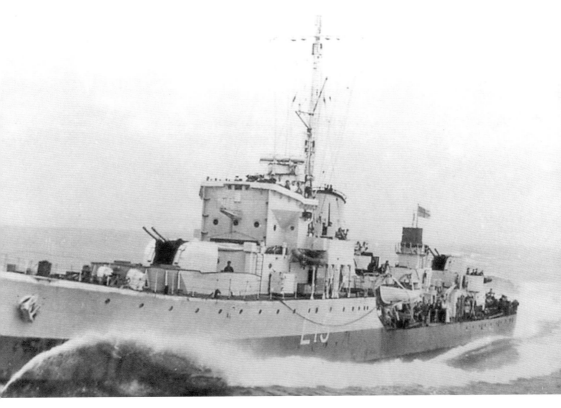

HMS *Eggesford* L15 (*above*) converted to *Brommy* F218 (*below*).

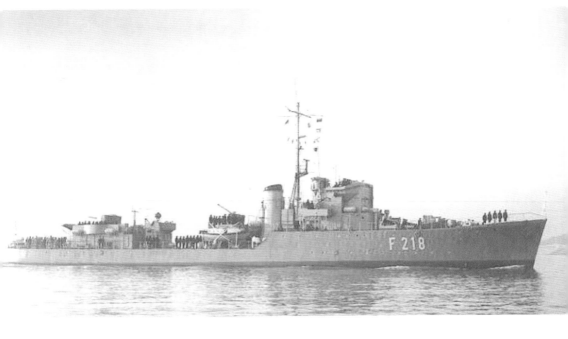

As well as cable laying, the vessel also had to accommodate the company's top executives on board and this was reflected in the outstanding quality of the woodwork carried out by the yard's carpenters. How strange that, later, these fine craftsmen were using handsaws, hammers and nails, labouring on the construction sites of the oil and power industry for twice the money.

Notwithstanding this craftsmanship, she had a relatively short life. At 48N 19W in the North Atlantic on 15 June 1959, a fire started in the accommodation and she was abandoned. While still on fire, she was towed to Falmouth by the tug *Wotan*. She was finally taken to the Netherlands later that year and scrapped.

The legacy of the dockyard apprenticeships spread much wider than just the sporting arena. A large number of my contemporaries stayed in the local area as I did. Many set up their own businesses, some of which are still going. Others switched seamlessly to the new oil industry in the haven, or went further afield to places such as the Llanwern Steelworks in Newport. The fact that these young tradesmen were able to adapt to the new industries was a tribute to the experience and quality of the training received during their apprenticeships. Shipbuilding in the dockyard came to an end in the early 1960s. The booming oil industry in the haven was given a £40 million grant by the government. On reflection, I can't help but wonder what impact a similar amount of support would have made to shipbuilding in the haven.

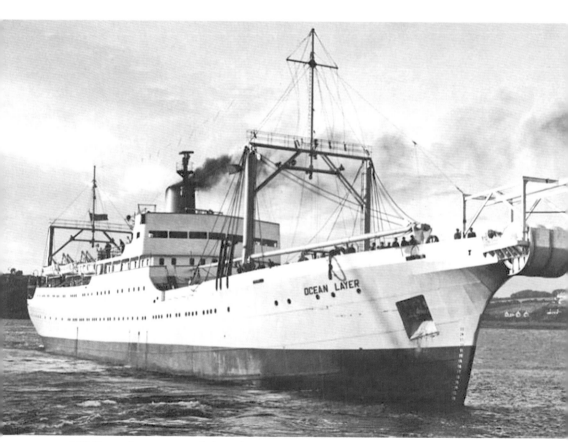

MV *Ocean Layer* on completion of conversion.

RAF Bomber Command,
1942-47

John Russell, as told to Ken MacCallum

John was introduced to flying when Sir Alan Cobham came to Pembrokeshire with his 'Flying Circus' in 1935. He went for a flight from Carew Airfield, sitting on his brother David's lap in the front cockpit of a Tiger Moth. His first flight lasted about half an hour and cost half a crown. John said that it was wonderful and gave him a lifelong love of flying.

Great Britain declared war on Germany on 3 September 1939. At this time, John was employed by his uncle, Mr E. C. Roberts, at Loveston Farm, Merrion, Pembroke. He had left Pembroke Dock County School in 1939 when he was fifteen years old. The country needed to eat so farming was being expanded and intensified. This meant that farming skills were at a premium and farm workers could not volunteer for active service in the forces. As ever, there was an exception; in this case, it was to serve as aircrew in the RAF.

John's flight
engineer's wings.

De Havilland Tiger Moth.

John joined the RAF on 21 December 1942, at just seventeen years old. Aircrew selection took place at Lord's Cricket Ground during January 1943. The candidates were divided into groups. Group One consisted of a pilot, navigator and bomb aimer. Group Two was a wireless operator and air gunner. Group Three was flight engineer. John wanted to be a pilot and joined the first group.

His Initial Training Wing (ITW) was at Torquay. There, while doing the 'dinghy drill', John was hit on the head and knocked unconscious by the quick and heavy release buckle of a parachute harness. By the time he had recovered and was released from sick bay, he had lost his place in that particular entry and joined another ITW at Newquay. John was unfortunate here in that Group One (Pilot-Navigator-Bomb Aimer) was full, so he joined as a flight engineer in Group Three instead.

John reckons that this accident could have saved his life, in that he missed out on pilot training in Canada. Of this training it was said that you needed an excellent navigator, loads of fuel and an equal amount of luck. This was because the flying training took place over a vast, relatively featureless and uninhabited part of the dominion.

The title of flight engineer would appear to be a bit of a misnomer, because in addition to the engineering side of controlling the engines, fuel and electrics, John was, effectively, the second pilot. The flight training for this was both long and intensive. Initially, the theory took place on the ground at Weston-super-Mare. Then, the introduction to practical airmanship using a 'link Trainer' (an early and successful form of flight simulator) happened at RAF St Athan. It was an introduction to basic flight manoeuvres, such as stall recovery.

After St Athan, John was posted to RAF Finningley in Yorkshire for the start of the airmanship course proper, with flight time starting on the De Havilland Tiger Moth. This was a two-seat biplane, a light trainer aircraft that was used extensively in the RAF and

Commonwealth air forces for basic flying training. For the more advanced training, he moved up to a twin-engine aircraft with dual controls. For John, it was the Avro Anson. This aircraft was a pre-war design developed from a 'feeder' airliner, and had been used by the RAF Coastal Command and Bomber Command. It had first flown in 1935 and was slow, only capable of 160 knots at 7,000 feet. It had a range of less than 800 miles. By 1939, it was already obsolete as a bomber and was mainly used for communication and aircrew training during the Second World War.

The next move was to RAF Wigsley, an Operational Training Unit (OTU) in Lincolnshire. For the first time, the training here brought a complete crew together and they flew in a Vickers Wellington.

The Wellington, initially classed and used as a heavy bomber, made its last bombing raid over Europe on 9 October 1943. However, it was in front-line service throughout the war in the Coastal Command. It was a tough aircraft by virtue of its 'geodetic' construction. The fuselage was formed by an aluminium lattice over longitudinal frames that could absorb a lot of punishment, both from new pilots and by enemy action, as the photograph below shows.

By the spring of 1944, John and the crew had completed the airmanship side of their training on the Wellington at the OTU. The first operational flying was on the Short Stirling out of RAF Skellingthorpe, also in Lincolnshire. The Stirling was a large aircraft; the flight deck had good all-round visibility and was protected by an armoured bulkhead aft. It was the only four-engine heavy bomber that had dual controls for the pilot and flight engineer. It also contained the navigator's position, while ahead of this was the position for the bomb aimer/front gunner.

The Stirling was the first four-engine heavy bomber designed for the RAF. It first flew in May 1939 and entered service in 1941. It handled well and had the reputation of being a 'gentleman's aircraft'. It was reputed to be able to out-turn both the Junker 88 and Me 110 night fighters, which made it popular with some. But the Stirling did have some quite severe operational limitations. The realistic operational ceiling, when loaded, was less than 12,000 feet. This was below the main bomber stream, so the Stirling became

Avro Anson in flight.

Vickers Wellington returned with severe damage from an anti-aircraft fire hit.

the first target of German night fighters and anti-aircraft guns. It had a range of only 500 miles with maximum bomb load, and the largest bomb that could be fitted in the bomb bay was 2000lb. By December 1943, it was withdrawn from first-line bombing operations. It was then used for mine laying, electronic countermeasures and the like. The final major and successful use of the Stirling was as a glider tug and troop transport during the land campaign for Europe.

In spite of the comments above, John liked the Stirling, considering it to be a 'pilot's aeroplane'. He much preferred it to the Halifax on the grounds of its reliability, toughness and manoeuvrability. During the time that John was at 1160 Operational Conversion Unit at Swinderby, again in Lincolnshire, he had the experience of an engine failure. The propeller was feathered, speed and height were reduced and the aircraft returned to Swinderby. Here there was very low cloud and a crosswind. The aircraft was instructed to land at a diversion airfield at Newark. By this time it was dark, and the markers of the Drem system were seen ahead.

The control tower was given a call to say that they were coming in 'on three and joining the circuit'. On the downwind leg, acknowledgement was received and they continued to the funnel. Flaps and wheels down, the aircraft was committed to landing on the single runway at Newark. With only three engines, there was no hope of overshooting, recovering and going round again. As the approach continued, a large four-engine aircraft was seen to be taxiing onto the same runway to take off. The only thing that could be done was to smartly swing to the left and land on the grass alongside the runway, a last-minute manoeuvre that was safely executed.

When reporting to the tower, it was found that the Drem system at Newark and Swinderby overlapped and the Newark airstrip system had not been switched on, even though they though they knew that a Stirling, with one engine out, was coming in to land. Two aircraft and their crews had been uncomfortably close to being written off.

The Drem system referred to above was a system of lights that was initially developed for night flying to allow single-engine aircraft to be guided to the end of the runway flare path. The name is not some cute acronym, but the name of the Second World War airfield in Scotland where the station commander, Wing Commander Atcherly, devised it. It was simple and effective, consisting of a circle of shrouded, white lights round the field at about 2,000 yards radius. They were on 10-foot poles, masked, and could only be seen if the aircraft was in the correct position and on course. The outer circle led the aircraft down to the funnel lights and on to the runway flare path. This had indicator lights that showed the pilot the start and end of the runway, the correct glide path and distance indicators. The system was so successful that the Air Ministry made it standard at all stations.

June 1944 was the date of John's first operation on a Stirling of Squadron 61. He was told that he was going 'gardening' and would be planting 'vegetables'. This was, in fact, mine laying in Hardangerfjord, which leads to the port of Bergen. Mine-laying operations were termed 'gardening' and the target was usually named after items such as fruit, flowers, trees, vegetables, fish and shellfish. For some reason, Hardangerfjord was called 'bottle'. This was one of a series of mine laying operations that had a threefold purpose: to disrupt the seaborne transport of men and materials around the north-west European coast; as

Short Stirling being bombed up.

part of the bluff of Operation Fortitude and to help with the cryptanalysis of German Ultra radio traffic.

Operation Fortitude was the deception plan used by the Allies in 1944. This indicated that the main target for invasion was anywhere other than Normandy. As part of it, a fictitious '4th British Army' in Scotland was preparing to invade Norway. This part of the plan was termed 'Fortitude North', and was taken seriously by the Germans. They maintained several divisions in Norway for the remainder of the war. John and the 'gardening' operations were an integral part of this. 'Gardening' did have another meaning and use in the cryptanalysis being carried out at Bletchley Park. The Germans, particularly the German Navy, the Kriegsmarine, would sometimes use repetitive plain text in their encrypted messages. The British termed this a 'crib', and it was found to be a very effective tool for deciphering messages sent on the Enigma machines of the German Navy. To extend this, Bletchley Park would request that areas that had been previously mined and swept should be mined again. The idea was that if, as was likely, the local naval command would report this activity, words such as 'Heil Hitler', 'Minen' and location names would be repeated in the report. This was claimed to be a very useful tool in deciphering Enigma messages, invaluable for the team at Bletchley Park. From mid-May 1944, at Bletchley Park, the teams were working four hours on, four hours off. During this period, German signals were decoded that showed that the German High Command continued to believe in the 4th Army and its preparations for the invasion of Norway.

For this 'gardening' operation, the Stirling carried four mines and the raid was timed to reach the target area at first light, around 0400 hours. They flew 'low and slow' up the fjord and the channels between the islands to lay the mines. This meant flying at an altitude of 50 to 100 feet, at a speed of 150 knots. The squadron suffered no losses, no German fighters appeared, and the anti-aircraft batteries protecting Bergen and its approaches were positioned on the plateau above Bergen. This was a combined operation in that, later in the day, the B17s of the 8th United States Army Air Forces (USAAF) interdicted and shot up the minesweepers working to clear the mines. B17s were used as machine gun platforms rather than bombers. The minesweepers were hampered in that they had to maintain a steady course and slow speed when sweeping, making them easier targets.

In late September 1944, Operation 'Market Garden' took place. It was the ill-fated attempt to drive a corridor by airborne and ground forces, to capture the bridges up to and including Arnhem. Maximum effort was required. By this time, the Stirling had been developed for use as a glider tug. John's Stirling was modified by removing the rear turret so that it could tow a Horsa glider. Once the glider released the tow, the tow rope was recovered by hand to the Stirling. This task fell to the unemployed rear gunner.

Towards the end of 1944, the Stirling was taken out of service as a first-line bomber. John and the complete crew were posted to RAF Swinderby for additional airmanship instruction and a conversion course for the Avro Lancaster. This station was home to the No. 1660 Heavy Conversion Unit under the control of the No. 7 training group. The course lasted about a month and John joined 61 Squadron, of 5 Group, flying Lancasters. The squadron was based at RAF Skellingthorpe, close to Lincoln. 61 Squadron shared the base with 50 Squadron, also flying Lancasters.

61 Squadron had the distinction of completing more operational bombing raids over Europe than any other Lancaster squadron in Bomber Command. The Avro Lancaster had been developed from the twin-engine Avro Manchester, and became the most successful of the 'night bombers' in the Second World War. It entered service in 1942, had a maximum speed of 240 knots and a range, with light load, of 2,700 nautical miles. Its service ceiling was in excess

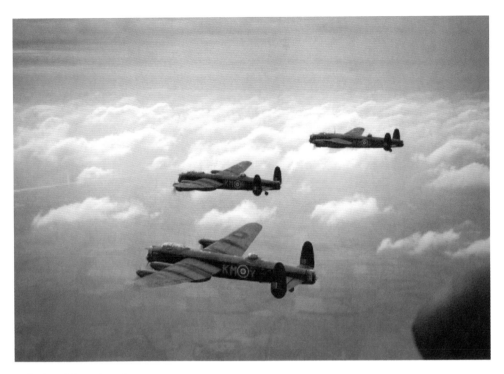

A flight of three Avro Lancasters.

of 20,000 feet and its maximum bomb load was 22,000lbs. The cockpit, or flight deck, was on top of the fore part of the bomb bay, under a large, glazed canopy. The pilot's seat was on an elevated section of the left-hand side of the aircraft, protected by an armour plate behind and beneath the seat. (The only bit of steel on the aircraft!) The pilot had his parachute as a cushion. The flight engineer was to his right and lower down, on a collapsible 'second dickie seat'. The main control switches were to his front with the engineer panel on his right-hand side. For the flight engineer to take over as pilot, 'George', the auto-pilot, had to be engaged and the pilot and flight engineer executed a swift little 'two step' to change positions.

In addition, John had the task of deploying 'window', bundled strips of metallised paper that were cut to lengths that would be best reflected by the range of frequencies used by the German radars. The type and amount of window deployed followed a predetermined pattern. This was intended to confuse the German radar defences by masking the aircraft from the anti-aircraft, searchlight and night fighter control radars. In addition, the search and early warning radars would be confused as to the strength and target for the raid.

The bomb aimer/front gunner was in the nose compartment of the aircraft. Immediately aft of the cockpit were the navigator's and wireless operator's positions. All of these positions were heated, unlike the mid, upper and rear gunner. The cramped confines of the turrets meant that they couldn't wear the bulky sheepskin 'Irvin jackets'. This meant that they had to rely on electrically heated suits and gloves, with wiring and connections prone to breakage and disconnection. The mid-upper gunner had an uncomfortable canvas seat suspended in the turret. The rear gunner entered his turret via a pair of doors, leaving his parachute outside the turret. It was often easier to put his boots in the turret first and put them on as part of the process of getting into the turret. If he had to bale out, he had to

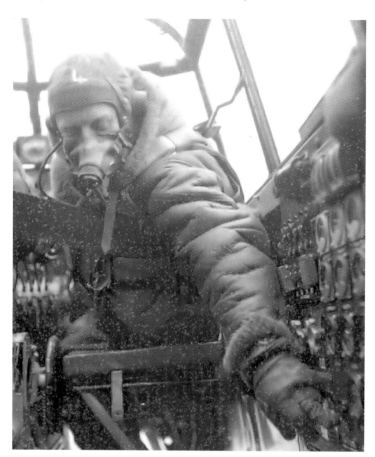

Left: A flight engineer checking switches in the cockpit of a Lancaster before taking off.

Below: The bomber stream, showing 'window' deployed.

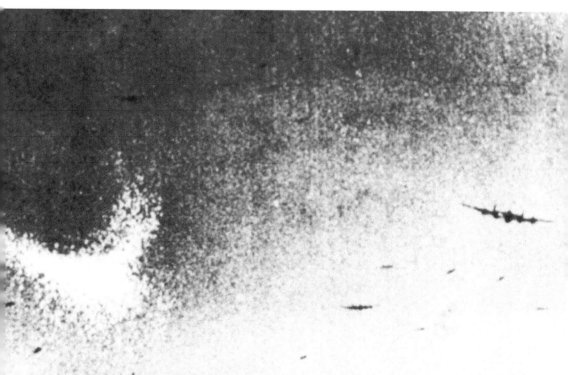

open the doors, collect and clip on his parachute, rotate the turret to the beam position and exit backwards. All this in the dark in a gyrating aircraft!

The rear gunner was the main defence against night fighters. On spotting a night fighter, the rear gunner was supposed to report it in a particular format: 'Night fighter aft, corkscrew left/right.' This manoeuvre was a rolling, diving, climbing turn and it should have moved the Lancaster out of the night fighter's line of fire, allowing the rear and mid-upper turrets on the Lancaster to engage the night fighter. In John's crew, the rear gunner did not, strictly, adhere to this procedure and was given to reporting and repeating 'night fighter f— off.' It must have been effective, as John is here to tell the tale.

By early 1945, 5 Group comprised fifteen squadrons with a nominal strength of 300 Lancasters. In addition, there were ten Mosquitoes and Mustangs used in the target marking role. Each squadron had twenty Lancasters divided into flights A and B. Squadrons were required to have one flight at readiness at all times. The squadrons were based at airfields clustered around Lincoln. They were among the finest squadrons in the RAF. The low level target-marking techniques developed by 5 Group, 617 and 9 Squadron in particular, were unique and claimed to be the most accurate in Bomber Command.

On a raid, the bombers did not fly in formation but were organised in a stream. The take-off times varied but the controlling factor in bomber separation was height, so there were individual streams of bombers separated by height. Once the target was reached, they would bomb the target markers that had been deployed by the Pathfinders. New target markers were laid in succession and 'walked up' the target so that the total selected area was bombed. The bomb loads varied according to the type of target. The picture shows a typical load of a 4000lb blockbuster, with the remainder of the load being incendiary bombs.

John's first operational trip in a Lancaster was with 61 Squadron. It was a raid on a synthetic oil refinery at Essen in early February 1945. The raid, carried out by 192 Lancasters, was successful and there were no losses. The raid of 26 February 1945 over the

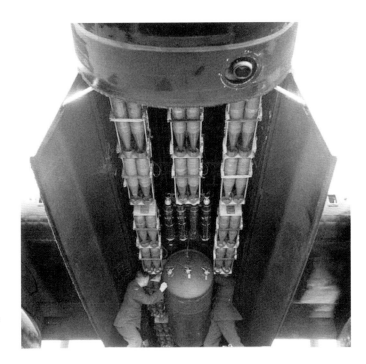

The bomb bay, loaded with a 4,000-lb 'Cookie', incendiary bombs and 'window containers'.

Dortmund-Ems canal was called off as the target could not be defined due to cloud cover. The Lancaster had had a full load of 1000lb bombs with thirty-minute delay fuses. As the flight engineer, John had to calculate whether or not there was sufficient fuel for the aircraft to return to their base at Skellingthorpe and whether the all-up weight was within the safe limit for landing. They could and it was, so it was decided to return to Skellingthorpe with the full bomb load.

On approaching the circuit at Skellingthorpe, the crew saw a large explosion on the ground. At the time, they took it to be the result of enemy action in the form of a German intruder aircraft. They were given instructions to divert to Waddington. Here they were the last aircraft to land after 5.5 hours airborne and were instructed to park as far away from any of the station facilities as possible.

The tower then informed them that they did not want to have the same accident as had occurred at Skellingthorpe, when a Lancaster that had been on the same raid landed with a full load of bombs and parked up in dispersal. The safety clip on the nose fuse of one of the bombs had come off, allowing the vane on the nose fuse to rotate and render the bomb live. The fuse was a thirty-minute delayed action and it detonated after landing when the Lancaster was parked up at the dispersal point. The whole of the bomb load, fuel and ammunition in the Lancaster blew up; four ground crew were killed, a further twelve were injured by the explosion and another four Lancasters were damaged.

The following operation was a raid on the Dortmund Canal, aimed at one of the canal pumping stations and a synthetic oil plant nearby. John's aircraft was hit and the wing and flaps were damaged by anti-aircraft fire. This happened homeward bound over the Frisian Islands, after bombing the target. On returning, they were diverted to Wittering, where there was a 3.5-mile-long grass runway. They landed safely.

One of the last raids that John was on was a joint operation with 50 and 61 Squadrons and a group of 62 B-17s from the USAAF. It was to take place at dawn and the targets were the U-boat pens and Blohm & Voss yards building the new type 22 U-boats at Hamburg. The B-17s were flying above the Lancaster squadrons at over 20,000 feet. The B-17s were not flying straight and level or on course over the target area. As a result, John's Lancaster

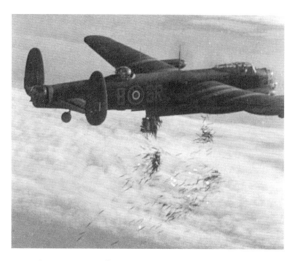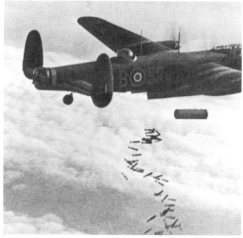

A Lancaster dropping window, then a 4000lb Blockbuster and incendiaries on a raid over Duisburg, 1944.

was hit by incendiaries from the B-17s. They did not explode or ignite, as there had been no time to arm the fuses. The raid suffered heavy losses from the day fighters sent up to intercept them. Eight Lancasters were shot down. The final raid was to attack the synthetic oil refinery at Lutzkendorf. Of the 258 aircraft of Bomber Command, six were lost.

Immediately after the war in Europe, the squadron was involved in Operation Exodus. This was the repatriation of POWs. They were mainly from Brussels in Belgium and Bari in Italy. Each trip, they brought up to twenty-four POWs home. A total in excess of 74,000 were repatriated by this means.

They also ran 'Rhine tours'. This was taking ground crews and the Women's Auxiliary Air Force (WAAFs) on trips to the bombed areas of Germany, which allowed them to see just what the air war over Germany was all about.

Following this, John was posted to RAF Silverstone in Northamptonshire (now a racing circuit) as an instructor in 'airmanship'.

But this did not last long. A joint force from the RAF, Royal Canadian Air Force (RCAF) and Royal Australian Air Force (RAAF) was being formed to continue the war against Japan in the Far East. This was Tiger Force. John was selected for Tiger Force and posted to 83 Squadron, at Coningsby, which was a Pathfinder Unit. 83 Squadron had a history: it had been part of 5 Group and then 8 Group of the Pathfinder Force. It was one of the original Pathfinder squadrons in the RAF.

The major problem with the bombing war over Japan was the distance involved. Lancasters had been designed with the European war in mind. The Lancaster was due to be replaced by the Avro Lincoln, a much larger bomber with increased capacity and range. It was expected that they would be available in significant numbers by 1945/46. Okinawa was intended to be the main base for Tiger Force; even so, it was still around a 1,500-nautical-mile round trip to southern Japan. Work to extend the range of the Lancaster included the trialling of a large saddle tank on top of the fuselage for extra fuel. It was not popular with the aircrew and did not prove successful. Instead, an extra fuel tank was fitted to the rear of the bomb bay of the Lancaster, which meant that the mid-upper turret was removed. In addition to this, a new colour scheme was adopted, with white upper surfaces and black underneath. An in-flight refuelling system was attempted; this system continued in use after the war. The first operational use was during the Berlin Airlift. Today it is a standard procedure.

Tiger Force was never completely deployed. John, with his Lancaster, had reached north-west India when the two atom bombs were dropped on Japan by American B-29s. This was the end of the war in the Far East. John returned to RAF Silverstone in 1946 and was demobbed in 1947.

(As told to Ken MacCallum)

Sorties Carried out by 61 Squadron 5 Group, February to April 1945

Date	Target	Sorties	Losses	Detail
04.02.45	Bottrop/Essen	192	nil	Synthetic oil refinery
13.02.45	Dresden	796	6	5 Group were the first wave, followed by Lancasters from 1,3 and 6 Groups. The next day, American B17s dropped another 800 tons of bombs on Dresden.
26.02.45	Gravenhorst/Mitteland Canal	154	nil	Raid recalled, cloud obscured target. Jettisoned Bomb load in North Sea.
03.03.45	Dortmund/Wanne-Eichel	128	nil	Canal Pump station and coal/synthetic oil plant. Flak damage to wing and flaps. Landed at Wittering on the 3.5-mile-long grass runway.
06.03.45	Sassnitz	191	1	Easternmost deep water in Germany. Today it has the former RN submarine HMS *Otus* as a tourist attraction.
09.03.45	Hamburg	62	nil	Blohm & Voss (B&V) shipyard
20.03.45	Böhlen	224	9	Synthetic oil plant
23.03.45	Wesel	80	nil	In support of Operation Plunder, the airborne and ground assault across the Rhine. The RAF was complimented by Montgomery on the effectiveness of the raid.
31.03.45	Hamburg	360	8	Joint dawn raid with Americans. U-Boat pens and B&V building yards. Losses were due to day fighters. John's aircraft was hit by incendiaries from B17s above.
04.04.45	Norhausen	243	1	Military area. Tunnels were used to assemble V2 rockets. A low level attack.
08.04.45	Lutzkendorf	231	6	Synthetic oil refinery and storage depot.
April/May	Germany-Italy-Holland	-	-	Operation Exodus to bring home British POWs and supply drops of food to Western Holland.

The Voyage Home, 1939

Ken MacCallum

Preamble

The 'voyage home' invoked in the title was from Singapore to the UK. Mother and I were passengers on the HMT *Dilwara*. *Dilwara* is a Jain temple complex on Mount Abu in the State of Rajasthan, North West India. The temple is famous for the exquisite marble carvings and archways, which are unsurpassed and considered to be masterpieces of their type.

My father, a sergeant in the Royal Artillery, had gone home earlier in the year on the RMS Rawalpindi, a P&O liner. She was soon to be converted to an armed merchant cruiser. On arrival in the UK, my father was posted to an anti-aircraft training camp at Portreath, Cornwall, as part of the rearmament and expansion of the Army. My mother, five months pregnant with my brother Cyril, and I followed a few months later on the troopship HMT *Dilwara*. No 'civvie boat' comfort for us!

We had been on Singapore Island, at Changi, since 1936. My father served with the 32nd Coast Battery of the 9th Heavy Regiment of Changi Fire Command. He was with either the 6-inch Mk. VII or 6-pounder twin Mk II close defence batteries. Today, the site of these batteries is a coastal tanker terminal. Our married quarter was at B6 Quadrant Road, Changi. Both the quarter and the barracks HQ of 9th Heavy Battery remained in 1996, used by the Singapore Defence Force. My memories of Changi are of sea, sun and sand, plus all the associated fun that was available. The only drawback was that I was brought up without being able to speak 'Pembroke'. That had to wait until I got home to Llanreath.

War with Germany was declared during the course of the homeward voyage of the *Dilwara*. This meant that from Port Said to Southampton the *Dilwara* sailed in convoy. My memories and account of this voyage are based on data gleaned from admiralty records at the Public Record Office and other historical publications, plus my recollection of events that occurred more than seventy years ago.

Singapore to Suez

We sailed on board the *Dilwara* from Singapore on 20 August 1939. I was approaching five years old and my first recollection of the voyage home is of Colombo, lovely, spicy smells and being taken to see a lighthouse in the middle of the town. This had been built as a clock tower in 1857 and the light was added in 1860. By 1952, the light was obstructed by buildings and was moved. In 1953, when I went ashore at Colombo from the MV *British Advocate*, the unlit structure was all that remained.

The *Dilwara* arrived at Aden on 3 September 1939. For about four or five days prior to arrival at Aden, *Dilwara* had been accompanied by the town class cruiser HMS *Birmingham*.

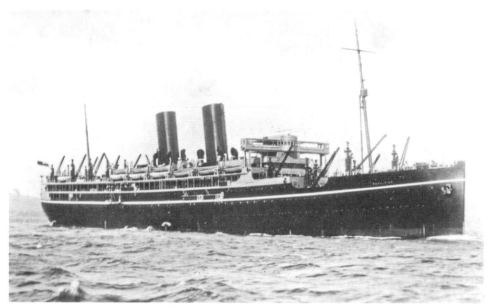

Above: RMS *Rawalpindi* before conversion to an armed merchant cruiser.

Left: Sgt MacCallum and family on the foredeck hatch of the RMS *Rawalpindi* before she sailed from Singapore to the UK.

Below left: Sgt and Mrs MaCallum at the RE sports dayat the Padang, Changi.

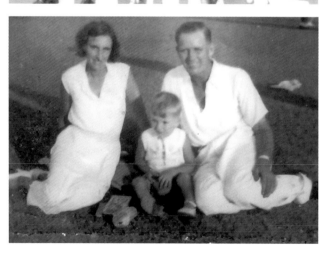

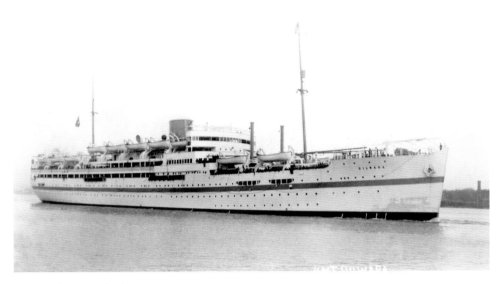

HMT *Dilwara*, as built in 1936.

It would seem that the Admiralty were certain that war was imminent and wished to protect one of their assets. I remember going ashore at Aden in a large, open wooden boat with a noisy engine. I think that it must have been a lifeboat, as I don't think that a troopship would have carried a special 'run ashore' boat at that time. The other main memory was the strong smell of the sea at the bottom of the companionway. Almost certainly, the *Dilwara* was well fouled with all manner of tropical marine growth, accounting for the sea smell.

I was ashore with my mother in Aden and it seemed no time at all before we were rounded up and herded back to the boat by a very large Royal Marine. I can vividly remember his red-and-white peaked service cap and starched khaki uniform. Going back to *Dilwara* in the boat, all the grownups seemed to be very serious as war with Germany had recently been declared. So I sat quietly and tried to look all serious, just like the grownups. The *Dilwara* then sailed for Suez.

On arrival at Suez, the *Dilwara* transited the canal to Port Said and moored between buoys opposite the port and canal office building. There was a large number of merchant and warships there. We were not allowed ashore, but picked up more passengers. Unknown to my mother or me, a Llanreath family – Mrs Ambrose, née John, and her daughter Charlotte – boarded the *Dilwara*. They had been accompanying her husband Lt Ambrose of the 1st Wessex in Egypt.

One ship was pointed out to me as being special, as the flotilla leader of our escort. Frank Mills, a Llanreath man, was a stoker/ERA on board the HMS *Hardy*. He later went on to win the Distinguished Service Medal (DSM) at the Battle of Narvik, where his captain, Warburton-Lee, was awarded a posthumous VC.

Convoy Blue 1, Port Said to Gibraltar
HMT *Dilwara* sailed with Convoy Blue 1 from Port Said on 9 September 1939. It was the first westbound convoy of the war from Port Said. Once clear, the twenty ships of the convoy formed up in five columns of four rows. The columns were three cables apart, with two cables between ships in each row. One cable equalled 200 yards. The theory was

HMS *Birmingham*.

that by advancing on a broad front, the convoy presented less of a target for a waiting U-boat.

HMT *Dilwara* was the commodore ship at the head of column three in the first row. The convoy commodore, either a senior MN (Merchant Navy) master with experience in the Royal Naval Reserve or a retired RN flag officer, was responsible to the senior officer of the escort for the control and handling of the convoy. The escort for the convoy was the 3rd Division of the 2nd Destroyer Flotilla. HMS *Hardy* was the leader; the remainder of the division were HMS *Hasty*, *Hereward* and *Hostile*.

Three days later, it was my fifth birthday, which we celebrated on board with a big cake. We used to eat in a large mess room and were served by Indian stewards. My main memory of the mess room is the all-pervading smell of pea soup, fiddles on the long tables, white tablecloths and a woman being seasick and falling backwards out of her chair. Our cabin was very small, with just room for the four bunks and a foldaway washstand. I thought that that was really smart piece of kit. There were four of us in the cabin: two mothers and two boys. I didn't like the other boy so we squabbled. It ended up with the two of us having a competition over how far we could spit. Not surprisingly, the two mothers fell out because of this. I did improve with age.

The convoy route had been determined by the NCSO at Port Said. The experience of these early convoys showed that routing needed to be better coordinated. It was suggested that routing should come from a single authority and that the single authority be responsible for all Allied convoy routing. Our convoy, Blue 1, narrowly missed a French convoy that was on a reciprocal course on the night of 14 September. A single convoy authority and fixed routes would have avoided this.

The convoy carried out zigzags by day and convoy speed was 9 knots, which gave a speed in advance of 8½ knots. Zigzags were discontinued at night. Signalling, station keeping and manoeuvring were exercised energetically and showed rapid improvement. During an exercise for, or possibly an actual 'emergency turn' around 16 September, there

HMS *Hardy.*

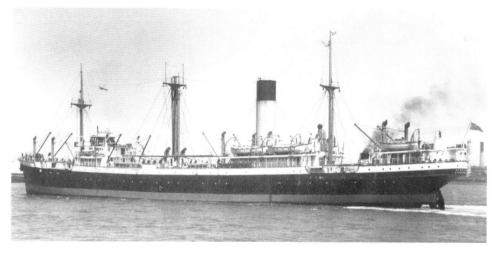

SS *Stentor.*

was a collision between *Dilwara* and another ship in the convoy. The other ship was the SS *Stentor*, a Blue Funnel Line ship on our port side.

I was woken up with all sorts of bells and gongs ringing, before being hurried along alleyways and up stairways with the other passengers and made to stand in lines on what I now know is the boat deck. I was still in my pyjamas and dressing gown. A man in a peaked cap fastened a lifejacket on me. It was dark but not cold, and I don't remember being at all concerned. I had no real idea what was happening. My mother was very worried, as she had picked up the wrong handbag, the one without the money. After what seemed a very long time to me, we went back to the cabins. The convoy, now with two damaged ships, proceeded on its way to Gibraltar.

The convoy arrived at Gibraltar on 18 September 1939, with no further incident. However a problem with effectively screening the convoy off Gibraltar became apparent. About half of the convoy, for which there were no harbour pilots, was ordered to stop and wait well outside the defended area of the port. This meant that there was an extended line of ships,

several miles long, all stopped. They presented an easy target that was impossible to screen effectively. The ships had to be 'urged' to enter the patrolled area of the Bay of Gibraltar.

Apart from the unexpected meeting with the French convoy and the collision involving *Dilwara* and Stentor, the voyage from Port Said was without incident. On arrival at Gibraltar, the *Dilwara* was taken in hand to repair the collision damage. From what I remember of being in Gibraltar, the *Dilwara* was in the dry dock and I was shown the big dent and hole in its side with staging and men working. Apart from that, I can remember little about Gibraltar, except from being in a large open and dusty place with monkeys. It must have been apes on the rock of Gibraltar.

Convoy HG1, Gibraltar to Southampton

After repairs, *Dilwara* became part of Convoy HG1 formed at Gibraltar. The convoy sailed from Gibraltar at 1500 hours on 26 September 1939. It was the first UK-bound convoy of the war from Gibraltar. There were twenty-eight merchant ships in the convoy. Another large and fast passenger ship was the SS *Largs Bay*, owned by the Aberdeen & Commonwealth Line and managed by Shaw Saville & Albion. Eighteen of the ships, including the Stentor, had been in Convoy Blue 1, another ten joining at Gibraltar. All the merchant ships were in their peacetime livery. The 'Ocean Escort' and senior officer escort of the convoy was HMS *Colombo*, a light cruiser of the Carlisle class built in 1919. The remainder of the escort was the Polish destroyer ORP *Blyskawica*.

Prior to sailing on 26 September, a convoy conference was held ashore at 1030 hours. The convoy was due to sail at 1400 hours, but it was 1500 hours before all ships were underway. On sailing, the Strait of Gibraltar was swept by an anti-submarine destroyer screen ahead of the convoy. This was maintained until 2200 hours on the day of sailing. At the same time, aircraft from Gibraltar maintained air cover over the convoy during daylight hours, until dark on 27 September. At this time, North Front airfield at Gibraltar had not been constructed. So the aircraft would have been from the six Saunders-Roe London II seaplanes of 202 Squadron, 200 Group, based at Gibraltar.

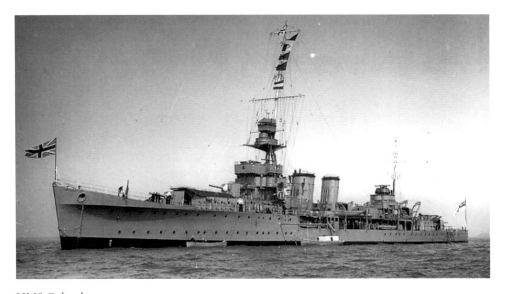

HMS *Colombo*.

On clearing the protected area at Gibraltar, the convoy was assembled in four rows, each of seven ships. Convoy speed was 8 knots and during daylight hours maintained a zigzag.

By day, Colombo was stationed within the convoy. Blyskawica took up station about 3 miles ahead, zigzagging independently across the front of the convoy. By night, Colombo patrolled ahead, zigzagging independently, but within visual signalling distance of the convoy. This released Blyskawica, which then dropped to a position astern of the convoy. The reasons for this were to keep off shadowers and to keep down any U-boats ahead of the convoy. There was the subsidiary role of keeping neutral ships away from the convoy.

During the first full day at sea, emergency turns were exercised. This exercise was repeated after dark. By the next day, the weather started to worsen. At 2000 hours on 28 September, *Blyskawica* detached, as she was low on fuel. My memory of this convoy is of a large number of ships. The escort vessels appeared to me to be destroyers, one of which was in the middle of the convoy on our port side. I now know that this was HMS *Colombo*, and that the destroyers joined us much later at a rendezvous in the Western Approaches.

Mother was pregnant at this time, and I used to go with her when she went to see the ship's doctor. I had to wait outside in a grey painted alleyway on chairs that were steel, cold and very hard. It was very boring for a five-year-old boy. One day on the promenade deck, I wanted to get a better look at one of the ships in the convoy and climbed up on the rail. A member of the crew

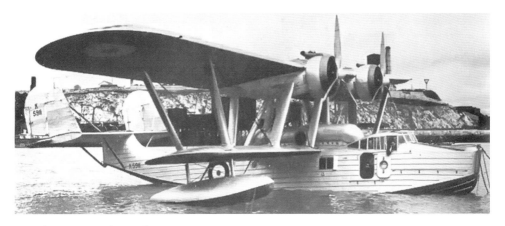

Saunders Roe London II Flying Boat.

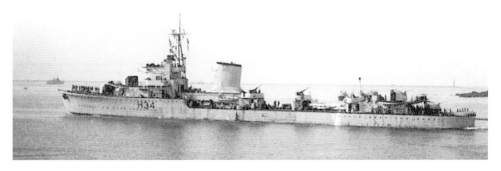

ORC *Blyskawica*.

grabbed me. This gave me one hell of a fright, so I had to cry, even though he was being very nice to me. He was dressed in navy blue and had a 'milk churn' hat, so I guess that he was either one of the quartermasters or one of the RN personnel on board. Mother was quite concerned. This must have been in the Bay of Biscay, as it was very rough. I can clearly remember seeing the forefoot of the ship in the next column to us coming clear of the water.

On 1 October, the ships exchanged convoy stations to conform to their revised ports of destination. The weather had deteriorated further, convoy speed was reduced to less than 4 knots and the zigzag was abandoned. This delayed arrival at the rendezvous point where the local escort was to join. At 1400 hours on 3 October, four destroyers of the 5th Destroyer Division rendezvoused with the convoy. On 4 October, the convoy split. Eight ships, escorted by two destroyers, proceeded to Irish Sea ports as convoy HG1A. At 1400 hours on 5 October, HMS *Echo* and HMS *Intrepid* took over as escort for convoy HG1. Our original escort proceeded to Devonport.

It was not known at the time, but one of the reasons that the *Dilwara* was not attacked was that on the first day of the war, the SS *Athenia* had been torpedoed and sunk around 250 miles north-west of Ireland. The U-30, commanded by Lt Lemp, was responsible. There were about 118 casualties, children and Americans among them. Hitler immediately put a ban on unrestricted submarine attacks on passenger ships, as he did not want to drag America into the war. It was not until August 1940 that Hitler finally lifted all the restrictions that he had placed on submarine warfare. Cpl Hitler could have saved my life! While *Dilwara* survived the war, Lemp was not so fortunate. He was drowned or killed when in command of U-110 and attacking convoy OB318 in the North Atlantic on 9 May 1941. U-110 was blown to the surface by depth charges from the corvette HMS *Aubrietia* in company with the destroyers HMS *Broadway* and HMS *Bulldog*. U-110 was then abandoned by her crew before being boarded and captured by members of the crew of *Bulldog*. Lemp was possibly drowned while attempting to swim back to the submarine, having realised that the U-boat was not sinking, or he succeeded in swimming back to the U-boat only to be shot by the RN boarding party already on board. It depends who you believe.

Postscript

The *Dilwara* arrived at Southampton on 5 October 1939. On disembarking, there was the large cabin trunk and sundry bags from the cabin, plus trunks and packing cases stowed in the hold that had not been wanted on the voyage. The story goes that mother took one look at the pile, made sure she had the handbag with the money, took me and departed. The baggage was consigned to the tender mercies of the railway company, probably the GWR. It worked, as it all arrived in Llanreath a few days later.

Notes

The HMT *Dilwara* was a purpose-built troopship of 11,050 gross tons, built in 1935 and managed by the British India Steam Navigation Company. She was a motor ship and survived the war, later taking part in Operation Demon, the evacuation of the Army from Crete in April 1940. She was subsequently converted to the Landing Ship Infantry in 1942, and was involved in landings in North Africa, Sicily, southern France and Burma. After the war, she reverted to trooping and was rebuilt in 1950 to carry 325 passengers and 750 troops. In 1960, she was sold to a Chinese shipping company, ending her days on the pilgrim run from south-east Asia to Jeddah. She was finally taken out of service and scrapped in 1971.

HMS *Hardy* was the flotilla leader of the 2nd Destroyer Flotilla of H Class ships. HMS *Hardy* was sunk at the first Battle of Narvik on 10 April 1940, where

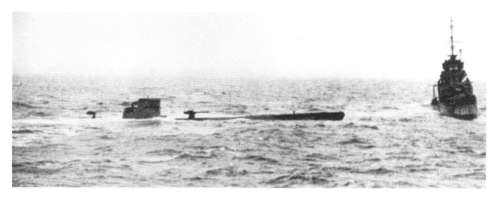

U-110 and HMS *Bulldog*.

Captain Warbuton-Lee was posthumously awarded the VC. The new HMS *Hardy* was built in 1943. She was the senior officer escort of convoy JW56B, from Loch Ewe to the Kola Inlet, when on 30 January 1944 she was torpedoed and heavily damaged by a GNAT (German Navy Acoustic Torpedo) from U-278. She could not be saved and was sunk by HMS *Venus*.

The convoy report by HMS *Colombo* is fascinating and detailed. It clearly shows our lack of preparation for war. Also, the range of speeds of the ships in the convoy meant that the slowest vessel dictated the speed of the convoy. This made it less safe for ships such as *Dilwara* and *Largs Bay*.

HMS *Colombo* was one of a class of cruisers designed at the end of the First World War. During the Second World War, she served as a 'trade protection' cruiser up until 1940, when she was converted to an AA cruiser, in common with the bulk of the class. Whites of Cowes built the Polish destroyer ORP *Blyskawica* in 1936. When it became clear that Hitler was not going to heed the ultimatum from the UK and France, she sailed to the UK. Her name translates as 'lightning'.

Finally, the recollections of an eleven-year-old schoolboy are below. I must admit that today I have no recollection of changing ships in *Colombo* or of sitting in a lifeboat after the collision with the *Stentor*, but it was a long time ago.

My Voyage from Singapore
We sailed from Singapore in August, 1939. Our first call was at *Colombo* in Ceylon, where we changed from an ordinary steamer onto the P&O liner *Dilwara*. Next we called at Aden for passengers and went on to Suez. We were held up a week there until a convoy was made up. It was composed of about thirty ships, with an escort of one cruiser and a lot of destroyers. We now sailed through the Suez Canal, and on our way to Gibraltar we were rammed amid ships by a cargo ship. It happened about ten o'clock at night, and I remember how I woke up and heard the alarm bell ringing. We rushed on deck and had to sit in the lifeboat until it was found that we would not sink, then we went back to our bunks. The ship was laid up a week at Gibraltar to be repaired and when at last we left we had a patch of steel plates over the hole. When we got into the Bay of Biscay it was very rough and once I saw a ship's bow and keel out of the water. We then carried on to Southampton where we landed. We had arrived home after two months and ten days at sea.

K. MacCallum, Form IIA
Reprinted from the *Penvro Journal*, July 1946

Lucky Philip

Master Mariner Lt Cdr Philip Vanner RD Rtd

My topic is 'Lucky Phil' and some of his 'salty' adventures. I was lucky to be chosen as a Trinity House pilot. The 'salty adventures' is a reference to some of the acts of pilotage that I was called upon to perform. This paper is really a history lesson, as I have not performed an act of pilotage since September 1988, so please forgive me for any lapses of memory.

A charter, the 'Guild of Brotherhood', was granted in the reign of King Henry VIII on 20 May 1514. The charter was called for because of the scarcity of mariners in England at that time, along with the real fear of 'foreigners learning the secrets of the King's Streames'. Trinity House has stood on Tower Hill for 200 years. Its crest, Trinitas in Unitate, denotes the religious connection that had existed for over 500 years. This can be traced back to Archbishop Stephen Langton in the thirteenth century, so the first indications of Trinity House were well in evidence 200 years before the 1514 charter. It was in 1594 that the Lord High Admiral relinquished to Trinity House the beaconage, buoyage and ballastage that were added to its powers of pilotage regulation.

The self-employed Trinity House pilots, who had previously been appointed and administered as well as annually relicensed by Trinity House, became employees of the CHAs (Competent Harbour Authorities). All pilots were medically examined for physical fitness before being employed by the CHAs, and thereafter were subject to their rules and regulations. Today, Trinity House performs two functions. It is the general lighthouse authority for England and Wales, and an administrating charity for the relief of mariners.

I have often been asked about my role as a marine pilot and the expertise required to perform this role well. Primarily, a pilot must be a good actor. But he should also have full knowledge of his district. This includes the buoyage, beacons and lights that mark the channels, sandbanks and other hazards. In addition, there are the regulations of the port. He should have vast experience of ships and their idiosyncrasies. This can only be obtained through many years at sea and qualifying as a master of a foreign-going ship. The training to achieve this can never start too early.

Mine began as a cadet on HMS *Worcester* at the age of fourteen in September 1948. I had sat and passed the entry examinations for both HMS *Conway* and HMS *Worcester*. They, along with Pangbourne, were the recognised public schools for the training of young men to follow a career as deck officers in the Merchant Navy. They were the civilian equivalents of Sandhurst, Dartmouth and Cranwell.

Following this were three MOT examinations to enable one to command a merchant ship. The examinations were termed 'Certificates of Competency', and were separated by periods of 'sea time'. It could take up to ten years to become eligible to take command

of a merchant ship. My first command came at the age of thirty. HMS *Worcester* and I parted company in the summer of 1950. I started my three-year apprenticeship when I joined the general cargo ship Eastern City in Sunderland in September. Periods of seafaring alternated with time ashore studying for my certificates. I also had to complete my Royal Naval Reserve training. By 1964, I had been promoted to Lt Cdr RNR and had, briefly, held command of a Bank Line ship.

In 1965, I married the lovely Monica. Like the majority of seafarers, I swallowed the anchor and searched for a 'shore job'. I worked for Milford Haven Marine Services, Westminster Dredging and qualified as a Mersey pilot. As well as this, I continued with my RNR training.

In February 1968, I was interviewed at Trinity House for a position as a pilot. I was successful and spent twenty happy years with Trinity House before retiring through ill health in late 1988. A Trinity House marine pilot should be innovative, imaginative and inventive, among many other things. One story to illustrate the point is that of a third officer of a large passenger ship, who ultimately became a Trinity House pilot for the London district. It concerned a funeral, or rather two funerals, at sea.

Funerals at Sea

Preparations had been completed for a burial at sea. The third officer was in charge of the burial detail. The corpse, sewn in a weighted canvas shroud, was on a hatchboard under a Red Ensign. The captain was on deck, Bible in hand, beside the corpse. The vessel had stopped. On the signal to commit the body to the deep, the hatchboard was raised so that the corpse would slide slowly from under the ensign into the sea. Unfortunately, the hatchboard was too dry and the canvas shroud stuck firmly to it. The third officer instructed the detail to raise the board. Still there was no result. It was only when raised

Aqueduct. (*Courtesy of Grenville Jones*)

Trinity House, Harwich. (*Courtesy of Philip Vanner*)

so that the corpse would slide slowly from under the ensign into the sea. Unfortunately, the hatchboard was too dry and the canvas shroud stuck firmly to it. The third officer instructed the detail to raise the board. Still there was no result. It was only when raised vertically that the body obliged to commit. Naturally, the third officer received a strong reprimand for the botched funeral.

So it was that the next voyage produced another dead passenger. The same third officer was in charge and placed over the bulwark rails. The corpse was placed on the hatchboard under the flag. All was now ready, but the third officer wanted to be sure that the corpse would slide satisfactorily. He instructed the detail to lift the board slightly to check that the body would slide.

Away it went over the side, while the ship was still at full ahead. The captain was waiting for the third officer to report that all was ready for the committal. Alas, no corpse. Quickly, the situation was retrieved. The bo'sun was to prepare another 'body', made up from pudding fenders, rope and a few big shackles. It was sewn into a new canvas shroud and placed on the hatchboard under the Red Ensign. When the bosun was ready, the third officer would report to the bridge. The ship was stopped and, with due reverence, the body of fenders, rope and shackles was committed to the deep. As the captain remarked afterwards, the corpse slid over the side beautifully. The third officer had redeemed himself through his imagination, inventiveness and innovativeness!

Pilots Must be Good Diplomats
I always seemed to have trouble with Russian ships and personnel. I remember an occasion in a Russian passenger ship proceeding to Tilbury in dense fog. We were passing off Thameshaven close to starboard, when the captain became very agitated about an

outward-bound radar contact in the Lower Hope, seemingly on a collision course with our port bow.

I patiently told him that the situation was not serious. I had already been in VHF contact with Gravesend Radio, and also bridge to bridge with the outward vessel's pilot. He was due to alter course at the West Blyth buoy, long before he came anywhere close to ourselves. I had to be very patient and diplomatic, because I couldn't have an excited captain on my hands. Fortunately, I was able to calm his fears, but it could have meant a dangerous situation.

I was presented with a tricky situation by another Russian ship that I was travelling in. I had just anchored the vessel in the Zulu anchorage off Southend. We were going to be there for several hours before going in to Tilbury. I had been shown to a cabin when, a few minutes later the chief officer arrived with a guitar and a bottle of whisky, and I found out that he had loving on his mind as well. I was not amused, not patient and certainly unsympathetic.

Another story of a Russian deck officer, whom I had to show the error of his ways, occurred after around two hours of piloting his ship down the Barrow Deep and altering to port to enter the Oaze Channel in clear visibility. This officer came up to me and told me that I should be altering starboard, not port. He pointed to the chart where he had been painstakingly plotting the ship's position since I had been on board, slyly keeping tabs on the pilot. He had somehow managed to navigate his way down the Black Deep to a point when, if in the Black Deep, an alteration to starboard was necessary to make an approach

(*Courtesy of Grenville Jones*)

to the Knock John Channel. I patiently and diplomatically attempted to explain that we were in fact in the Barrow Deep Channel. I wonder if he ever thinks back on that. After all, he was the navigating officer.

Pilots Must be Cunning as Well

Pilots must be able to hold their own with the shore controllers, and always have an answer or excuse ready for everything. I am reminded of an inward-bound vessel, where it was alleged by a female Shore Control Gravesend controller that the pilot had neglected to report his vessel at Sea Reach No. 3 buoy, when he was engaged in reporting at Sea Reach No 7.

> Controller: Pilot, you did not report at Sea Reach No. 3.
> Pilot: Yes, I did report the vessel at Sea Reach No. 3.
> Controller: I didn't Roger you!
> Pilot: That would have been a miracle if you had!

MN and RN

Finally, a couple of stories for you. One from the MN and one from the RN. Both stories are about vessels at anchor. The first tells of the MOT candidate being examined for Second Mate Orals. The examiner asked him what he would do if he was on anchor watch with the wind freshening. The candidate said that he would let out more cable. The examiner seemed satisfied, but told the candidate that the wind was blowing very, very hard, and asked him what he would do now. The candidate let out more cable and dropped the other bower anchor. Again, the examiner asked the candidate what he would do if the wind was gale force. The candidate said that he would drop another anchor. However, by this time the examiner still hadn't got the answer that he had wanted and asked the candidate, 'Where are you getting all your anchors from?' 'The same place where you are getting all the wind', came the candidate's reply. Are you wondering what reply the examiner was looking for? There is a suggestion at the end of this piece.

My last tale of the sea concerns an anxious RN midshipman on anchor watch. Once again, the wind was freshening and the weather deteriorating. The midshipman called to the captain, 'weather deteriorating, Sir'. The captain replied, 'Thank you Mid, let me know if it gets any worse.' Sometime later, the midshipman called to the captain again, 'It's getting quite bad up here now sir.' The captain again replied, 'Thank you Mid, let me know if it gets any worse.' By this time, it was blowing really hard, the rain was sheeting down and visibility was extremely poor. The ship was snubbing on the anchor cable and showing some distress.

The midshipman again called the captain, 'Sir, it is very, very bad up here, the ship is swinging and snubbing the anchor cable, the rain is coming down in torrents and visibility is down to zero.' 'Thank you Mid, let me know if it gets any worse', came the Captain's response.

Later on, with the weather getting really out of control, the ship was swinging wildly and the anchor cable was stretched fully out. The wind was howling in the rigging, the rain was torrential and the sky was black. Thunder could be heard and lightning lit up the stormy scene. The ship was pitching and rolling alarmingly. By this time, the demoralised midshipman frantically called the captain, 'Sir, the wind is storm force up here, there is now thunder and lightning. I cannot see anything for the rain. The sky is dark and the radar display is snowed up too. The ship is swinging wildly at the anchor. The cable seems to be groaning and we are pitching and rolling too.' 'Thank you Mid,' came the reply, 'let me know if it gets any worse'. 'It can't get any worse,' said the midshipman, despairingly. 'Ah well Mid,' said the captain very soothingly, 'let me know when it gets better!'



"When I said Drop the pilot, I meant Drop the pilot and not to drop the pilot."

(*Image above courtesy of Grenville Jones*)

The MOT examiner probably wanted the Master and First Mate to go to the wheelhouse. The engineers would then be dragged from their beds and put on standby. Steam would be sent to the windlass. The bosun, chippy, apprentices and Foc'sle crew would stand by the forrad and the local port authority would be informed of the situation.

Ode to the Poop

Oh hasten my friends for Socotra's arriving,
And with her the chance of some buckshee imbibing.
Let us laud from the quay her official elite,
As they strut on the deck with their oversize feet.
Observe the Commander in pristine white suit,
At the end of a sixteen inch, he-man cheroot.
And the elegant Third busy ogling a bird,
The Cadet noting down every action and word.
While the dashing Fourth Mate you will readily own,
Cuts a right noble figure while working the phone.
Observe on the Foc'sle in right regal state,
And dazzling apparel, the honoured Chief Mate.
His crew all attentive in eye straining white,
Are proud to obey such a man of great might.
His Cadet standing by with a bright beady eye,
To please him would doubtless be ready to die.
The Chippy who stands at his brakes on tip-toe,
The dark visaged men in the lockers below.
In fact every man-jack I think you'll agree
Is a credit indeed to this great Company.

Now haste for the gangway is already lowered,
And 'tis well to be foremost among those on board.
The ale that awaits us will go in a trice,
Before reinforcements can cool on the ice.
For they truthfully say, so make no delay,
That the swift win the race and the strong win the fray.
But before we press on to partake of the cheer,
Prepared by the Purser and Chief Engineer,
I prithee one moment your proud glance to stoop
And regard with compassion – the man on the poop.
Observe how the Second Mate lacks all serenity
As he strives to make fast that unwholesome extremity.
With an air of dejection so utterly final,
His nose but a yard from the fireman's urinal.
The execrable stench from the Bhandary's bench
Would cause the most stalwart of heroes to blench.

His crew all look doleful and sullen and grim
As they peer forth from cavities dark and so dim.
And a definite aura of baffled frustration
Hangs around every man as he stands at his station.

Oh up on the Bridge how they chortle with glee
As they think of the poop with its fish-heads and ghee.
Where the garlic has drifted like snow in the scupper
Midst the week-old remains of the Deck Serang's supper.
Where the expectorations of Far Eastern nations
Have gathered for what would appear generations.
The sun deck that wards of the pure solar ray
Denying access to the clean light of day,
Collects all the rain and through many a crack
Directs the whole lot down the Second Mate's back.
Purgatorial Poop, with selection of pains
Devised by a sadist's demoniacal brains.
Beware as you move lest your clothing you soil,
For some fiend has coated the rails with fuel oil.
And the leads were designed by a tyro, whose mind,
Would have been better use if he'd left it behind.
To hurry is fatal; you'll find if you try,
As your feet from beneath you will certainly fly.
As you slide on the deck impregnated with butter,
To end in an undignified heap in the gutter.

When the pungent aromas of bad sanitation
Have conspired to produce a complete desperation,
The industrious Topass in manner so neat,
Spills a quart of carbolic all over your feet.
And splashes the rest with commendable zest
Wherever he thinks the effect will be best.
But though for a moment he masks the condition
Of fish in advanced stages of decomposition,
'Tis but a measure of passing respite
As odours creep back like thieves in the night.

The telephone stands on the sundeck above,
A position for which the Cadet has no love.
In solitude left to commune with his soul,
Amidst derelict stages and spare galley coal.
But though blinded by dust and old chippings of rust
He never deserts this position of trust.
Each order received he repeats through clenched teeth
Through a hole in the deck to the Second beneath.
While that worthy develops a neck like a gander
Popping up through the hatch like a U-boat Commander.

Oh, the spring 'neath the horsebox is hopelessly stuck,
We've bust two chain stoppers, beheaded a duck.
The Tindal with language, may Allah forgive him,
Sorts out the wire from the Ag-wallah's tiffin.
Though we're in a tight pinch yet we won't move an inch
'Till the Cassab's brown hen is removed from the winch.
And though on the Bridge they most ardently yearn,
To give the propellers just one little turn.
They must curb their impatience we fear
For we'll save all the livestock 'ere we say 'All Clear'.
Aye! Bowse her in forrad as hard as a rock!
Aye! Leave the stern sticking way over the dock!
And when for a little slack forrad we pray
Just telephone aft the curt words 'Heave Away!
Oh the men are past caring, the Tindal's despairing,
The Second has taken to bi-lingual swearing.
But an inch at a time she is coming a little
Doubtless due to the ship being bent in the middle.
And as long as the crew are not taken away
To turn out the gangway, 'We'll get fast today!'

 Anon.

Note

This poem is, unashamedly, for the mariners among us. It was published via Mariners-L
Archives on the web. The source is a list for ex-BISN Co. Mariners (www.biship.com).
The owner of the copyright is John Prescott and the poem is reproduced here with his
permission. It is a pity that the author is unknown. But I would guess him to have been, at
some time, a Second Mate with the BISN Co.

The poem is an evocative piece for any seafarer who has served on passenger/cargo ships
to the Far East. It is certainly applicable to the Martaban, a Paddy Henderson ship that I
sailed on from Milford Haven with a cargo of explosives and ammunition to Rangoon in
the late 1950s.

I remember it well!

 Ken MacCallum

Acknowledgements

The photographs, unless attibuted, are from the editor's private collection. The souce of the remaining photographs and illustrations are as acknowledged in the text.

I owe my brother, Roger, a tremendous debt for his skill and ability in taming the technology of that beast referred to as 'the computer'. To me it is like trying to impose order on a box of drunken baboons. Substantial help was given by members of the Pembroke Probus Club, particularly, Morgan Allen, Joe Barnikel, Gren Jones, Dai Holt, George Lewis and John Russell.

Probably most important of all was my wife, Evelyn. She was a model of supportive tolerance, particularly when software reared up and bit me where it hurt, which was a frequent occurrence.

ALSO AVAILABLE FROM AMBERLEY PUBLISHING

Pembroke Dock
A Bicentennial Look Back

Phil Carradice & Roger MacCallum

This fascinating book presents readers with a series of photographs
and old prints, illustrating the development of the town from the
first half of the nineteenth century to the present day.

978 1 4456 1774 9
96 pages, full colour

Available from all good bookshops or order direct
from our website www.amberleybooks.com